CW00517408

CAPTIVES

Written and compiled by William Butler, Ela Kaczmarska and Roger Kershaw

William Butler is Head of Military Records at The National Archives. He is a Fellow of the Royal Historical Society, sits on the Council for the Army Records Society, and is a Honorary Research Fellow at the University of Kent. His research is focused on the British Army in the nineteenth and twentieth centuries, and his previous publications include *The Irish Amateur Military Tradition in the British Army, 1854–1992* and *The Disparity of Sacrifice: Military Recruitment in Ireland during the First World War*.

Ela Kaczmarska is a Modern Eastern European historian and Publishing Executive at The National Archives. She has an MA in Holocaust Studies and has over thirty years of teaching experience in schools and universities. She has published several educational resources and articles for The National Archives.

Roger Kershaw is Head of Strategic Operations and Volunteers at The National Archives. He has an MA in Archives and Records Management from University College London and over thirty years' experience in researching records at The National Archives and other archives. He has published five books, including *Migration Records: A Guide for Family Historians*.

CAPTIVES

Prisoners of War and Internees 1939-1945

The History Press

THE NATIONAL ARCHIVES

First published 2024

The History Press
97 St George's Place, Cheltenham,
Gloucestershire, GL50 3QB
www.thehistorypress.co.uk

British Library Cataloguing in Publication Data.
A catalogue record for this book is available from the British
Library.

ISBN 978 1 80399 595 3

Typesetting and origination by The History Press
Printed in Turkey by IMAK

Contents

Introduction

The experiences of prisoners of war (POWs) and internees during the Second World War are crucial to the wider understanding of the conflict. The war, in many respects, was one involving the mass movement of people across the world and, though POWs (usually military personnel captured by enemy armed forces) and internees (civilians placed in captivity because they were the nationality of the country now at war with the nation in which they resided) were confined in camps for long periods of time, their story forms an important part of that history.

Captives explores the lives of individuals who were interned or imprisoned during the conflict. Those in captivity during the war had diverse experiences. Very few physically escaped and, instead, spent much of their war as POWs or internees. These captives also came from a variety of backgrounds and brought different experiences and skills to camp life. Keeping morale up in the camps was an everyday battle, and so having contact with the people beyond the confines of the camps was a major factor in the survival of the inmates.

Upon the declaration of war on 3 September 1939, some 73,000 UK resident Germans and Austrians became classed as 'enemy aliens' – civilians who were believed to be a potential threat and to have sympathy with the enemy's war objectives. By 28 September, the Aliens Department of the Home Office had set up internment tribunals throughout the country, headed by government officials and local representatives, to assess every UK-registered enemy alien over the age of 16. The majority

(66,000) were initially not interned but, by May 1940, with the risk of German invasion high, a further 8,000 Germans and Austrians resident in the southern strip of England found themselves in internment camps. The increase in numbers led to a serious problem with capacity within the UK, resulting in more than 7,500 internees being shipped to Australia and Canada. Internment camps were set up across the British Isles, the largest of which were on the Isle of Man.

Following the invasion of the Low Countries in Europe and the fall of France in 1940, thousands of British and Allied civilians found themselves interned by the German authorities. Likewise, British citizens in Italy faced internment following its declaration of war on Britain in June of that year. Civilians of the occupied Channel Islands were also considered for internment. Most would be interned in what became known as *Internierungslager* or *Ilags* and there were several hundred of these camps in France alone.

The imprisonment and treatment of POWs was historically governed by a series of conventions and laws. The Geneva Convention of 1929 had established the rules and duties of captors and captives, and came to shape the steps taken by respective countries to ensure the humane treatment of the latter at the outbreak of the Second World War. Many of these laws did not, however, cover the internment of civilians, nor were they applied fully by Japan, which had signed the Convention but not ratified it. Learning from the experience of the First World War, preparations had been undertaken to take in large numbers of both POWs and internees, while the Red Cross had a clearly defined role in ensuring that the laws and conventions were being followed.

Significant increases in the number of POWs occurred at various stages of the war, most notably when France fell to the German armed forces in May–June 1940; when Japanese forces captured Singapore in February 1942; and after the D-Day landings in June 1944. Many of these events, therefore, also dictated the scale of internment of civilians.

Over 170,000 Allied soldiers, sailors and air personnel found themselves POWs under Nazi or Italian authority during the Second World War. Germany had 248 POW camps, situated in Germany itself and in the occupied territories of Eastern Europe. They were segregated

War Cabinet memorandum by the Lord President to the Council

'Category A (dangerous)............................... 2,500
Category B (subject to restrictions)........... 5,500
Category C (not subject to restrictions).... 21,000'

(THIS DOCUMENT IS THE PROPERTY OF HIS BRITANNIC MAJESTY'S GOVERNMENT)

S E C R E T.

W.P.(G)(40) 170

COPY NO. ___13___

2ND JULY. 1940.

WAR CABINET.

INTERNEES AND PRISONERS OF WAR.

Memorandum by the Lord President of the Council.

1. On 11th June I informed the Cabinet (W.M.(40) 161st Conclusions, Minute 6) that Canada had undertaken to receive 4,000 internees and 3,000 prisoners of war. I intimated that the 4,000 internees would absorb the most dangerous characters among the Germans and Italians.

2. Since then, every effort has been made, on the direction of the Prime Minister, to arrange for as many internees as possible to be sent overseas.

3. I desire now to inform my colleagues of the present position and to bring to their notice certain difficulties which must be faced if we are to continue – as I think we should continue – the policy of sending internees out of the country.

4. The total number of male Germans and Austrians excluding prisoners of war in this country at the beginning of this year was 29,000, classified as follows:-

 Category A (dangerous) 2,500

 Category B (subject to restrictions).. ... 5,500

 Category C (not subject to restrictions) .. 21,000

Practically all Category A and B have been interned. Category C is in process of internment.

 The total number of Italian males was approximately 10,000, of whom 4,000 (including 734 reputed Facists) have been interned. 6,000, who have been in this country for more than 20 years, or are outside the age limits of 16 to 70 are still at liberty.

5. Canada has agreed to accept internees and prisoners of war to a total of 7,000; Newfoundland has agreed to accept 1,000 internees; and Australia and New Zealand, although the arrangements with these Dominions are not yet complete, are expected to take 6,000 and 4,000 respectively.

-1-

◀ The categorisation of civilian internees in the UK, 2 July 1940. CAB 67/7

> The international convention signed in Geneva on 27 July 1929. FO 93/1/141

and either housed officers (*Oflags*) or other ranks (*Stalags*). At its peak, over half a million German and Italian POWs were held in 487 camps across the UK – often segregated by officers and other ranks – while many more were transported to other Allied nations.

Though the safety net of the Geneva Convention meant that supplies, particularly food, were made available to POWs, non-officers were often required to work for their captors. Again, this work was strictly defined by the Geneva Convention, and prisoners could not carry out work related to the war effort.

Away from work, boredom could be an additional psychological strain on individuals, and so sporting activities and theatre productions were common, while most camps had libraries and religious provision to keep prisoners entertained and to ensure that their spiritual and intellectual needs were met. Prisoners could also send and receive letters from loved ones on a regular basis. Attempts to escape were a regular occurrence, and planning and implementing acts of resistance was a major part of everyday life in the camps.

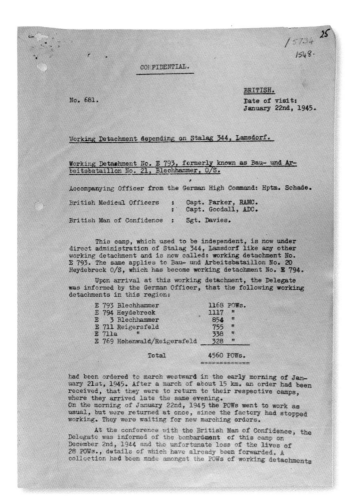

There were over 190,000 British and Commonwealth prisoners in the Far East. The 378 Japanese camps, often holding military prisoners as well as civilian internees, were in places including Japan, the Philippines, Malaya, Singapore, Thailand and Burma. Approximately 35,756 of these prisoners died in captivity: 27 per cent, compared to the 4 per cent who died in Europe. Notorious examples of ill-treatment included the forced 'death marches' and the building of the Thai–Burma railway, in which countless atrocities were inflicted on prisoners.

Gefangenenlager:		Staatsangehörigkeit:	Nr. der Liste:
Gefangenen-Nr.:		**England**	Seite der Liste:
Name:			Beruf:
			Religion:
Vornamen:			Dienstgrad:
Geburtstag u. Geburtsort:		Truppenteil:	
Vorname des Vaters:		Komp. usw.	Matr. Nr.
		Ort und Tag der Gefangennahme oder Internierung:	
Familienname der Mutter:			
		Verwundungen, Verletzungen oder Tod:	
Name u. Anschrift der zu benachrichtigenden Person:		wann und von wo zugegangen:	
Aufenthalt u. Veränderungen:			v 6

Over 130,000 Allied civilians (50,000 men, 42,000 women and 40,000 children) were interned in the Far East during the Second World War. Internees included colonial officials and their families, employees of European companies and the families of service personnel. They were held in hundreds of camps, often alongside those for POWs, located in many countries across the Far East, where conditions were often severe. Food was in short supply and overcrowding and disease were common, resulting in the deaths of over 14,000 men, women and children before their liberation in the summer of 1945.

The POW and internee experience – whether they were held in captivity themselves or knew an individual who was – touched the lives of hundreds of thousands of people across the world. This book highlights some of their stories and experiences using the vast material held at The National Archives in Kew. As the official archive of the UK Government, The National Archives holds a range of records that centre on the administration of POWs and internees, as well as records that highlight the personal stories of those in captivity. As such, this book also provides guidance to those interested in finding more of those stories in the archives.

The internment of civilians in Singapore by the Japanese authorities, 1942-45

'Citizens of all nations at War with Japan, including subjects of the Chungking Government are to proceed to the Padang at 10.30 a.m. tomorrow morning, 17th Febryary with enough clothing for 10 days, but must carry the packages themselves. Sick and wounded civilians to remain in their homes or in Hospital. Their addresses to be recorded.

Internees will be accommodated in 2 camps - one for males and one for females. No servants permitted except of the same race. Those engaged in Public Services to carry on and wear armbands signifying "SERVICE" in Japanese characters. "Public Service" will be defined later. It is unnecessary to take food.'

THE INTERNMENT OF CIVILIANS IN SINGAPORE BY
THE NIPPONESE AUTHORITIES - FEBRUARY 1942 to
AUGUST 1945.

INTRODUCTION.

The Nipponese Army High Command order calling for internment of enemy civilians in Singapore, as translated and circulated on February 16th 1942, read as follows:-

"Citizens of all nations at War with Japan, including subjects of the Chungking Government are to proceed to the Padang at 10.30 a.m. tomorrow morning, 17th Febryary with enough clothing for 10 days, but must carry the packages themselves. Sick and wounded civilians to remain in their homes or in Hospital. Their addresses to be recorded.

Internees will be accommodated in 2 camps - one for males and one for females. No servants permitted except of the same race. Those engaged in Public Services to carry on and wear armbands signifying "SERVICE" in Japanese characters. 'Public Service' will be defined later. It is unnecessary to take food."

In response to this Order some 1197 men, 145 women and 37 children assembled on the Padang whence they were marched to the first internment camps - Joo Chiat Police Station and Karikal Flats for men, and two houses near the Roxy Theatre (the property of the Sultan of Trengannu) for women and children. In the days which followed many hundreds more men and women were interned and on the 24th February a new camp for men was opened at the French Convent, Joo Chiat.

On 6th March all Male internees were transferred to Changi Gaol followed by the women and children on 8th March. With the exception of the old and infirm and mothers with infants in arms, the 7-mile journey to the gaol was made on foot, light baggage being carried. On transfer to Changi the numbers of internees had increased to 2290 men, 349 women and 63 children. Internees remained at Changi until May 1944, when they were transferred to Sime Road to be accommodated in the hutments formerly comprising the R. A. F. H.Q. Camp, Singapore. In the meantime their numbers had been increased by the transfer of internees from Penang Kuala Lumpur, Ipoh and other parts of Malaya, the internment of Europeans retained in Public Services after capitulation; and some Eurasians, Jews and other members of the domiciled population.

◀ CO 537/1220

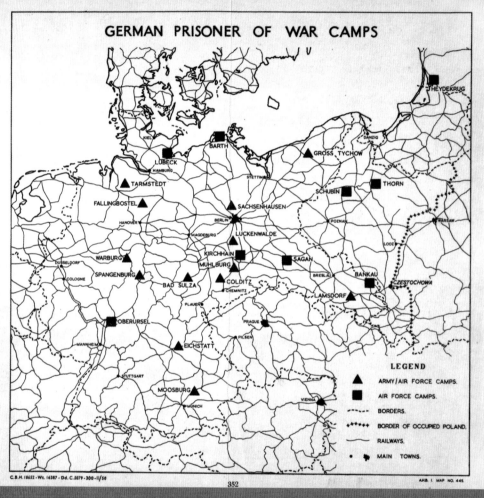

GERMAN PRISONER OF WAR CAMPS

HEYDEKRUG

KIEL
BARTH
LÜBECK
GROSS TYCHOW
HAMBURG
DANZIG
STETTIN
TARMSTEDT
SCHUBIN
THORN
FALLINGBOSTEL
HANOVER
SACHSENHAUSEN
BERLIN
POZNAN
WARSAW
MAGDEBURG
LUCKENWALDE
LODZ
KIRCHHAIN
DUSSELDORF
WARBURG
MÜHLBURG
SAGAN
COLOGNE
SPANGENBURG
BRESLAU
BANKAU
BAD SULZA
COLDITZ
CESTOCHOWA
CHEMNITZ
LAMSDORF
PLAUEN
OBERURSEL
PRAGUE
MANNHEIM
PILSEN
EICHSTATT
STUTTGART
MOOSBURG
VIENNA
MUNICH

LEGEND

▲ ARMY / AIR FORCE CAMPS.
■ AIR FORCE CAMPS.
---- BORDERS.
+++++ BORDER OF OCCUPIED POLAND.
—— RAILWAYS.
• MAIN TOWNS.

C.B.H.18652 - Wt. 16387 - Dd. C.5079 - 300 - 11/50

352

A.H.B. I MAP NO. 445.

∧ Map of some of the larger known POW camps for Allied personnel in Europe, created by the Royal Air Force, 1941. AIR 10/5725

1

Camps

A vast bureaucracy existed to ensure that the many hundreds of POW and internment camps in Europe and the Far East ran as smoothly as possible. Though many camps were purpose-built, large numbers were repurposed, such as the now-famous Colditz Castle. Some POWs and internees were also transported huge distances, even to the other side of the world, to be held far away from their homes or the places in which they were captured. POWs were usually segregated by nationality and race. As such, the experiences of individuals in these camps varied widely, while someone's age, gender, race and nationality also partly influenced life in captivity.

The 1929 Geneva Convention had stipulated the regular inspection of POW camps by representatives of neutral powers, and this generated huge numbers of reports on the conditions experienced by those held in captivity. Less was known about the conditions faced by those in Japanese camps, mainly because the Convention was not followed fully and information often had to be pieced together by Allied nations wanting to know about the experiences of its citizens. However, it was also possible to build a picture of captive life by looking at the letters or information sent out of these camps all over the world.

"MILAG" (Indian Camp)

(Military Camp)

No change has taken place since the last visit.

This camp is probably the best situated in the whole of the Marlag - Milag (Naval and Military Camp). Its 13 huts are built amongst trees. One obtains an excellent impression on arriving at the camp, as one does not see any barbed wiring.

The huts are spacious and well arranged. Each prisoner possesses three blankets. Nevertheless, the heating, as everywhere else, is inadequate. The lack of fuel is all the more keenly felt, since most of the prisoners come from countries where the climate is hot. The German authorities have given them permission to go regularly to collect wood from the forest.

The prisoners control the food that is allowed them by the authorities. The Delegate did not record any criticism on that point.

The question of clothing does not give rise to any claims, either. All the prisoners wear clothes that are in a good condition. However, they are rather short of shoes, and they lack repairing equipment.

Red Cross parcels are regularly distributed. Each prisoner receives one parcel per week. The Camp Leader has repeated his request to the Delegate - made during the last visit - that no further American parcels should be sent, but only Indian parcels. Although the prisoners do not dislike American parcels they prefer Indian parcels as a matter of religious principle.

The Medical service is in the hands of an Indian doctor. There is no actual infirmary. The doctor only deals with temporary, or slight maladies. As soon as a malady persists, the patient is sent to the Milag infirmary nearby.

Mail seldom arrives at the Camp.

The prisoners have not had any of the forms for postcards or letters to which they are entitled, on account of the destruction of the printing establishment. However, in February, each prisoner received 3 letters and 4 postcards; in March, only one postcard.

The religious life at the camp is intense. The theatre is used as a mosque. At every hour of the day the faithful turn to the East, read the Koran, and pray. The German authorities do not interfere in the least with these manifestations. Thus the prisoners have 400 copies of the Koran at their disposal.

The camp possesses a library of about 600 volumes in the English language; on the other hand, books in Bengali are very rare.

The prisoners do not work. They are not obliged to do anything but camp work (such as cooking, transport, chopping and collecting wood, etc.).

Relations between the German authorities and these prisoners are correct. The Commandant regards them with goodwill. The prisoners do not appear to be unhappy. No complaints have been made.

On the day of our visit, a certain number of prisoners were in the recreation hall. They play roulette and other games of chance, all day long. Tobacco and cigarettes serve as stakes. They also play for money. All this takes place amid a deafening noise, accompanied by wild gesticulations.

The Chief Officer, Herbert Walter Jones, No.3602, still undertakes the duties of Camp Leader. The "Homme de Confiance" is Amarullah, the Indian Camp Leader, No. 89523.

The/

These camps came in a variety of forms. Naturally, differences in their quality existed depending on which nation was detaining the prisoners. Most of those built in Britain had been established on requisitioned land and were purpose-built and barrack-like in appearance. Others, especially for officers, were established on the grounds of large estates.

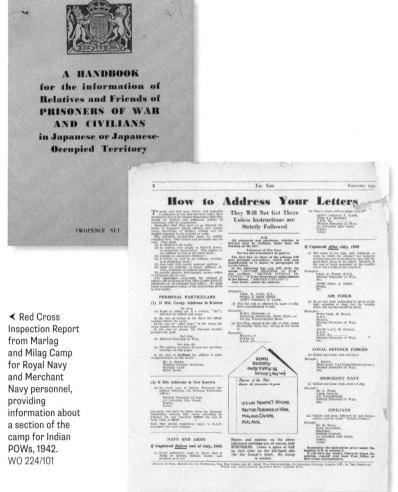

◄ A Handbook for the information of Relatives and Friends of Prisoners of War and Civilians in Japanese or Japanese-Occupied Territory, 1943. CO 980/205

◄ Red Cross Inspection Report from Marlag and Milag Camp for Royal Navy and Merchant Navy personnel, providing information about a section of the camp for Indian POWs, 1942. WO 224/101

◄ Instructions on how to correctly address a letter sent to a POW held in the Far East, February 1944. CO 980/121

▲ List of
locations of POW
camps for Axis
POWs in the
UK, 1939-48.
WO 199/339

| Colditz

Colditz, formally known as Oflag IV C, was arguably the most well-known POW camp in Germany. After the outbreak of the Second World War, the Renaissance castle was converted into a high-security camp for officers who were a security or escape risk, as well as for those who were regarded as particularly dangerous. Situated in Saxony in eastern Germany, on a rocky outcrop above the River Mulde, the Germans believed Colditz to be an ideal escape-proof site and, at its peak, it held over 800 POWs of a range of nationalities.

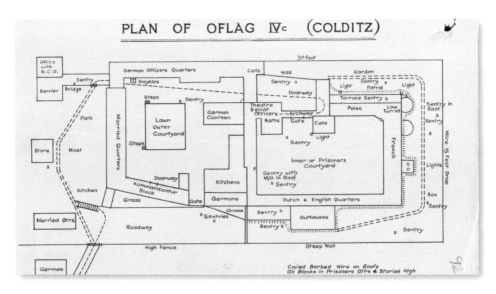

▲ Sketch plan of the layout of Colditz Castle produced by Airey Neave after his escape, May 1942. WO 208/3308

Colditz was a special camp for POWs who had proved themselves to be a nuisance at other camps, either because of their attempts to escape, or their general attitude towards the Germans. In addition, there were certain personnel who had been dropped as 'agents' in occupied countries and 'prominent persons' who were held at the camp because of their connection with the British royal family or with members of the British or Allied governments. It is believed that the Germans intended to hold these men as hostages to be used as bargaining chips should the occasion arise, though at the end of hostilities, owing to the chaotic conditions prevailing, this plan was never put into effect.

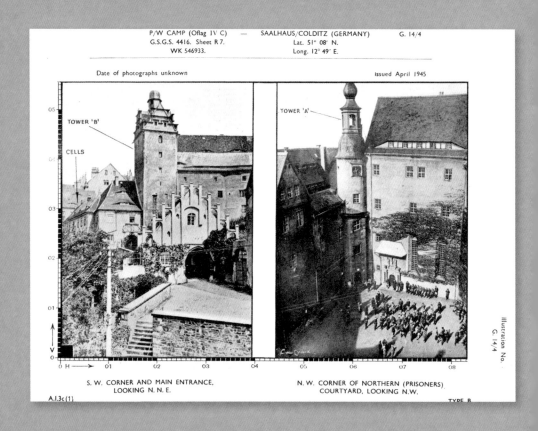

P/W CAMP (Oflag IV C) — SAALHAUS/COLDITZ (GERMANY) G. 14/4
G.S.G.S. 4416. Sheet R 7.
WK 546933.
Lat. 51° 08′ N.
Long. 12° 49′ E.

Date of photographs unknown

Issued April 1945

TOWER 'B'

CELLS

TOWER 'A'

S. W. CORNER AND MAIN ENTRANCE, LOOKING N. N. E.

N. W. CORNER OF NORTHERN (PRISONERS) COURTYARD, LOOKING N.W.

A.I.3c (1)

TYPE B

Illustration No. G. 14/4

Date of photographs unknown Issued April 1945

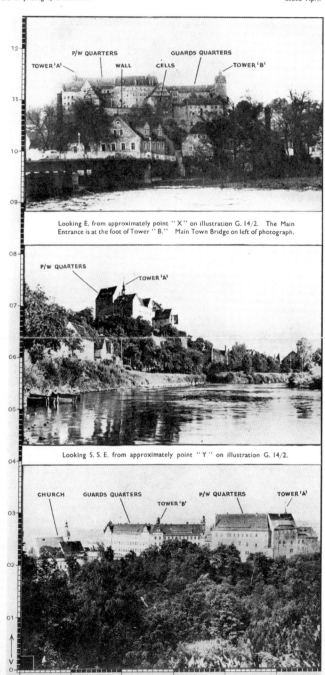

Looking E. from approximately point " X " on illustration G. 14/2. The Main Entrance is at the foot of Tower " B." Main Town Bridge on left of photograph.

Looking S. S. E. from approximately point " Y " on illustration G. 14/2.

◄ Photographs
of Colditz Castle,
1945. AIR 40/230

CHAPTER I

INTRODUCTION

1. ### LOCATION AND DESCRIPTION OF CAMP

OFLAG IV C (COLDITZ) was a special camp set up by the Germans for P's/W who had proved themselves to be a nuisance at other camps either because of their attempts to escape, or their general attitude towards the Germans. In addition there were certain personnel who had been dropped as 'agents' in occupied countries and the 'prominent persons' who were held at the camp because of their connection with the British Royal Family, or with members of the British or Allied Governments. It is believed that the Germans intended to hold these men as hostages to be used as a bargaining weapon should the occasion arise, though at the end of hostilities, owing to the chaotic conditions prevailing, this plan was never put into effect.

The surrounding country was hilly and the river valley of the Zwickauer Mulde was very steep-sided in the vicinity of the town, especially on the East bank, to the North of the camp, where the ground rose to a height of 720 feet. This river joins the Freiberger Mulde about two miles North-west of the camp, and they, together with two large wooded areas of the Forest COLDITZ, were the chief landmarks of the area.

The camp was built on the ruins of a castle situated in the SAALHAUS/COLDITZ district, about 12 miles South of DRESDEN and 24 miles South-east of LEIPZIG, on the North side of a small town called COLDITZ. Owing to the nature of its construction the Germans believed the camp to be escape-proof, because there was a dry moat with a high outer wall surrounding the castle. On the outer side of this wall there was a drop of nearly 30 feet to the terraced gardens below, which were built above a fairly high perpendicular wall.

The castle was divided into two main sections built round two small courtyards. The German officers and guards occupied the Southern section in which there were two main gates, one leading to the town, the other leading into the park. Both these gates were manned by

/sentries.

> Location and description of Colditz Castle taken from the castle's camp history, 1945. WO 208/3288

II Stalag Luft III

Opened in March 1942 and located in modern-day Poland, Stalag Luft III had capacity for nearly 11,000 POWs. Approximately 2,500 of these were Allied airmen of differing nationalities, many of whom had been shot down over occupied Europe and were held in a different compound to the remaining prisoners. The heavily fortified camp run by the Luftwaffe was purpose-built on sandy subsoil, while the barrack blocks that housed prisoners were elevated, supposedly to make escape by tunnelling impossible. It was the location, however, of two of the most famous escapes from camps in Europe (since depicted in film): the 'Wooden Horse' escape on 19 October 1943 and the 'Great Escape' on the night of 24–25 March 1944.

▼ Sketch layout of Stalag Luft III. AIR 40/229

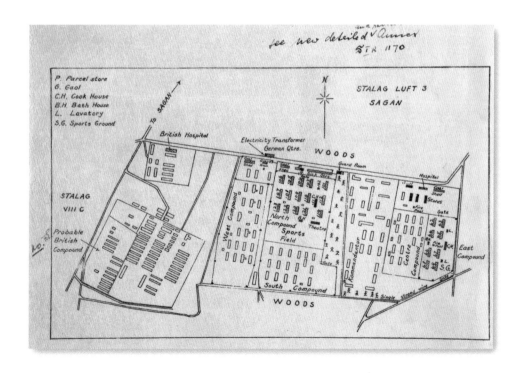

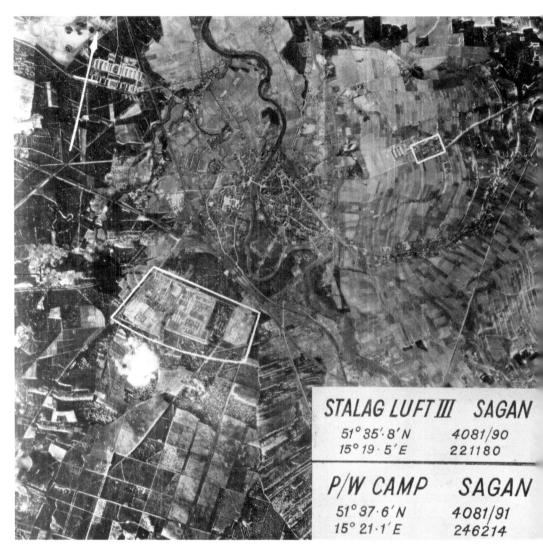

STALAG LUFT III SAGAN
51° 35'·8' N 4081/90
15° 19·5' E 221180

P/W CAMP SAGAN
51° 37·6' N 4081/91
15° 21·1' E 246214

▲ Aerial
photograph of
Stalag Luft III.
AIR 40/229

➤ Details about Stalag Luft III taken
from the Colditz Castle camp history,
including details about members held
at the camp and rations provided to
prisoners, 1945. WO 224/63A

STALAG LUFT III
(Men's Camp Air III)

PRELIMINARY NOTE

This camp now holds some of the prisoners who were already attached to it before being evacuated here.

At Sagan, Stalag Luft III consists of six camps:

North Compound : British and American prisoners
South " : American prisoners
East " : British prisoners
West " : American prisoners
Centre " : American prisoners
Belaria " : British and American prisoners

The total strength is about 10,500 officers and other ranks (more than 90% being officers)

The prisoners of the North and East Compounds alone have been evacuated, but the Senior Air Force Officer does not know where these sections have been transferred to.

These two compounds left Sagan on 27th January 1945, arriving at Marlag - Milag on 4th February 1945, after having had to abandon many of their number on the road. The present total strength of the camp is 1,926, (most of whom are officers).

QUARTERS

These prisoners occupy 12 huts to the east of Marlag "O". These huts which had to be built or moved in haste, are overcrowded. Some of the rooms are too full. As a general rule, these prisoners are cramped for space in their rooms. It is for this reason that one sees officers in the corridor, in the yard outside; and others again, preparing their meals out-of-doors.

Unfortunately, the authorities can do nothing more about it. The Camp Commandant gave the Delegate to understand that he had no further material available, and that they would have to be content with those huts.

FOOD.

The prisoners control the food supplies allowed them by the Detaining Power.

Quantities for the month of March:

Quantities per head in Gr.	Per month.	Per day	Protein Gr.	Fat Gr.	Carbohydrates Gr.	Calories Gr.
Meat	887.6	29.5	3.6	3.2	–	44
Margarine	533.4	17.8	0.3	15.1	–	141
Fat	243.6	8.1	–	7.3	–	68
Cheese	108.0	3.6	0.7	0.7	0.3	10
Bread	7896.0	263.2	18.0	1.0	122.0	581
Sugar	621.6	20.7	–	–	20.7	85
Jam	621.6	20.7	–	–	14.4	58
Potatoes	7112.0	237.0	4.6	–	38.7	178
Swedes	8552.0	285.1	2.8	–	14.2	70
Sauerkraut	600.0	20.0	0.2	–	1.0	5
Gherkins	200.0	6.7	–	–	0.2	1
Peas	80.0	2.7	0.6	–	1.7	9
Barley and other cereals	520.0	17.3	1.8	0.7	11.5	61
TOTAL			32.6	28.0	224.7	1311

STALAG VIIIB, GERMANY.

Name of Prisoner.	Colony.
Sgt. C. L. de Freitas, No. 1390726, British Prisoner of War No. 25082.	Br. Guiana.
L. Cpl. A. M. Hassell, B 66523, British Prisonerof War No. 26261.	Barbados.
Trooper D. R. July, 7889725, British Prisoner of War No. 10978.	Br. Guiana.
Trooper J. F. July, 7889603, British Prisoner of War No. 10977.	Br. Guiana.
Sgt. Christopher Lee, 754493, British Prisoner of War No. 37.	Barbados.
Sgt. Patrick L. Nelson, No. 13005774, British Prisoner of War No. 37167.	Jamaica.
Driver L. I. Pouyat, 187875, British Prisoner of War No. 21506.	Jamaica.
Private D. Quemby, 445/7787, British Prisoner of War, No. 14520.	Dominica.
Private Richard Rehfeld, 12890, British Prisoner of War No. 6735, E. 479.	Trinidad.

See u on this file.

Prncer Jack Davis.

▲ List of West Indian POWs held in Stalag VIII-B, 1943. CO 980/132

III Stanley Internment Camp

In the Far East, most POW and internment camps were established either in or on the grounds of prisons, or were built to resemble barracks and were scattered across Southeast Asia. Some camps contained both POWs and internees, held in separate compounds, while others were established exclusively for one or the other. Located on southern Hong Kong Island, Stanley Internment Camp held approximately 2,800 Allied civilian men, women, and children from January 1942 until the Japanese surrender in August 1945. Built around the grounds of Stanley Prison, internees lived in housing that had already been in existence in the area. Food and medicine were in short supply, but the presence of many doctors and nurses helped to ensure that no major outbreaks of disease occurred.

▼ Photograph of Stanley Internment Camp, 1943. CN 3/41

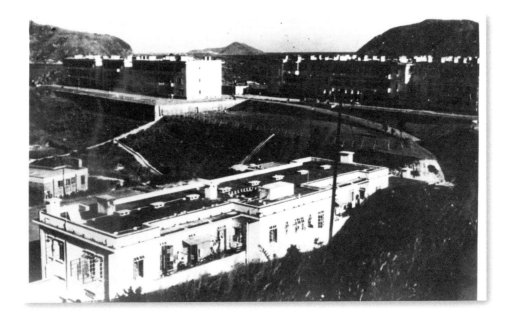

This report on a Hong Kong Civilian Internment camp is by a civilian re...ated under the Japanese-A...an-Canadian Exchange.

Life in Stanley Camp, Hong Kong

THERE are nearly 2,600 people in the Civil Internment Camp, Stanley; of these, about 60 are Dutch, 40 Norwegian, 15 Belgian, and the balance British subjects.

The camp is situated on Stanley Peninsula on the south-east corner of Hong Kong Island and about 10 miles from the city of Victoria (Hong Kong). It covers about 50 acres, is surrounded by barbed wire and guarded by Sikhs, formerly of the Hong Kong police. As a site for an internment camp it is good. There are lovely views all around, and there is a cool breeze most of the summer. It is, however, bitterly cold in winter.

When internees were first brought to Stanley in January, 1942, the place was in great confusion. The whole area had been fought over, many buildings had been damaged. Internees were thrown into this regardless of age or sex; men, women and children mixed up together. About half the people had no beds and many had no bedding.

To some extent these conditions have now been improved; men and women have, in most cases, been segregated in different rooms, and the majority, thanks mainly to the efforts of Dr. Selwyn Clarke, who was never interned but allowed to remain in town, have bedding and some form of bed even if, as in some cases, it is a few boards or a door, supported on boxes.

School for Children

Internees are lucky in having most of the Hong Kong University professors in the camp, as well as many of the Hong Kong school teachers, and a lot is done for adult education. Lectures are given on a great variety of subjects, and there are classes for many languages, both European and Asiatic. There is also a school which about 150 children attend. Books and paper are short, but a certain quantity has been obtained through the Red Cross delegate.

For recreation internees have bathing, which is allowed at certain hours during the summer months. This has proved a great boon. Unfortunately, there is rather a steep climb up from the beach and in 1943 many people found this too much for them.

There is a bowling green in the camp, formerly the property of the Prison Warders' Club, and this has provided a lot of pleasure.

The camp is moderately well supplied with reading material, a number of people having managed to bring books into the camp with which small libraries have been formed, and the Ameri-

cans succeeded in bringing their club library into the camp and left this when they were exchanged in 1942.

For news, internees have the "Hong Kong News," a paper published in English by the Japanese. From this, if one discounts the propaganda, one can obtain a good idea of how the war is going.

There is, of course, a good deal of work to be done as there are no servants in the camp. The raw rations are received daily from the Japanese, and these have to be divided and distributed among the three kitchens which cook for the camp. There is great competition for places in

> ### TO OUR READERS
> This journal devoted to the special interests of the next-of-kin of prisoners of war and civilian internees in the Far East theatre of war, will be sent to them each month in place of The Prisoner of War, which will no longer contain Far East pages.
>
> In certain cases next-of-kin of the "Missing" will also be included in our mailing list, but they must not assume that their relatives are prisoners of war.

the kitchens as workers there receive an extra half-ration.

Logs, which the Japanese supply, have to be cut up into firewood, and there is a party which cuts grass for the communal boiling of water for making tea. Other parties under the medical officer of health see that the camp is kept clean and do what they can to prevent mosquito breeding. Unfortunately, they are not allowed to do the necessary work

outside the wire, with the result that malaria has increased.

The women in the camp have played up very well. They do special cooking for children and the sick. They do the sewing for the camp and greatly assist in the concerts and plays which are frequently got up; in fact, they help generally to brighten life.

Inadequate Rations

The most serious problem of the camp is food: the rations supplied by the Japanese have never been adequate. As a result of the low diet, 1,460 people reported at the clinics during the first eight months of 1943 suffering from varying degrees of malnutrition diseases. The position would have been much worse had it not been for the shipment of Red Cross food which arrived in November, 1942. This consisted of, roughly, 87,500 × 12 oz. tins of meat, 50,000 lb. of sugar and a small quantity of dried fruit, vitamised caramels, etc. There were also about 1½ "Comfort" parcels per head. The tinned meat and sugar were issued to the camp in small lots and lasted until about June of 1943. During this period the health of the camp improved enormously. Beri-beri disappeared. Unless, however, further similar shipments reach Hong Kong in the near future, the health of internees will again be seriously jeopardised.

Clothing From Red Cross

A consignment of clothing also arrived through the Red Cross, together with the food. This was urgently needed as nearly all internees were seriously short of clothing. Unfortunately, the footwear which was sent was retained in Japan and never reached Hong Kong, with the result that many internees are reduced to wearing wooden clogs or going barefooted.*

What gives internees most pleasure is to receive a letter from home. The first English mail was received in November, 1942, and letters have trickled in at irregular intervals ever since.

There are priests of all denominations in Stanley, and church services are well attended.

In spite of the discomfort and hunger and the fact that there is no end in sight, the morale of the camp has always been high.

*Since the author left Hong Kong it has been reported that footwear has been purchased in considerable quantities.

Stanley Camp, before the occupation by the Japanese.

▲ 'Life in Stanley Camp, Hong Kong', extract from the POW magazine, February 1944. CO 980/121

Basic rations for those at Stanley Internment Camp, 1942

'The most serious problem of the camp is food: the rations supplied by the Japanese have never been adequate. As a result of the low diet, 1,460 people reported at the clinics during the first eight months of 1943 suffering from varying degrees of malnutritional diseases.'

INTERNATIONAL INTERNMENT CAMP -
STANLEY, HONG KONG.

Basic Ration.

(Scale laid down by the
Authorities)

			21st January 1942	25th March 1942
R i c e each person per day		½ lb.	5/16 catty
F l o u r 10 persons every other day		1 lb.	1 "
S u g a r 40 " per day		1 lb.	17.04 oz.
S a l t 50 " per day		1 lb.	10.65 oz.
Pea-nut O i l 50 " per day		1 catty	Half catty
B e a n s 10 " every other day		1 lb.	------
M i l k each child under 3 years		Half tin	------
Firewood each person per day		" catty	Half catty

N.B: The above scale (excluding milk) was for Adults only up to and including 24th March 1942, when the Scale was approved for all internees. Milk was issued to children under 3 years of age up to and including 24th March 1942.

Daily Average ration issued per person per day.

(O u n c e s .)

	February	March	April	May
Rice	8.520	6.66	7.52	7.55
F l o u r	.568	2.00	4.50	8.07
S u g a r	.394	.42	.42	.36
S a l t	.314	.21	.21	.34
Pea-nut O i l	.190	.21	.21	.21
B e a n s	.590	---	--	--
M i l k	7.000	---	--	--
F i r e w o o d	10.666	10.566	14.48	16.75

N.B: The averages for all foodstuffs (excluding milk) up to and including 24th March, 1942, are for all persons 3 years of age and over; as from 25th March, 1942, the averages are for all persons including children under 3 years of age.

The supply of milk ceased as from 28th February, 1942.

The supply of beans ceased as from 23rd February, 1942.

The averages shown under February are as from the 21st January, 1942.

◄ CO 980/82

IV Changi Camp

Following the fall of Singapore to Japanese forces in February 1942, Changi Prison and a nearby barracks were quickly turned into POW and internment camps for Allied military forces and civilians captured on the island. It housed approximately 50,000 mainly British and Australian prisoners, many of whom were soon transferred to other labour camps to work on the construction of the infamous Thai–Burma 'Death Railway'. Twelve thousand prisoners working on the railway perished as a result of the harsh conditions.

▼ Sketch map of Changi Camp, 1943. WO 32/14550

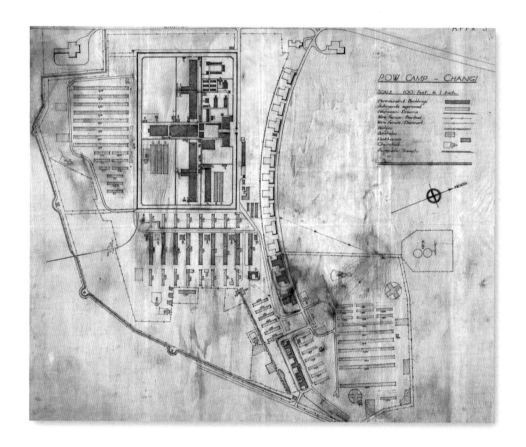

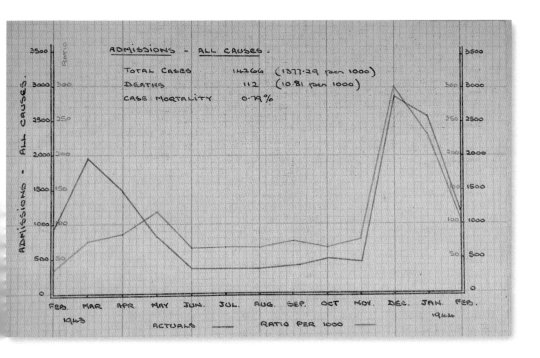

ADMISSIONS - ALL CAUSES.

TOTAL CASES	14266 (1377.29 per 1000)
DEATHS	112 (10.81 per 1000)
CASE MORTALITY	0.79%

FEB. MAR APR MAY JUN. JUL. AUG. SEP. OCT NOV. DEC. JAN. FEB.
1943 1944

ACTUALS ⎯⎯ RATIO PER 1000 ⎯⎯

∧ Hospital
admissions at
Changi Camp,
taken from the
Annual Medical
Report, 1943–44.
WO 222/1384

V Ilag VIII/H Tost

Ilag VIII/H, situated in the village of Tost, in Upper Silesia (now in
modern-day Poland), was originally an asylum but was converted
to a cramped camp for civilian internees in 1940, housing over 1,000
occupants. Many of these were British and Canadian nationals living
and working in France and the Low Countries, who were arrested as
enemy aliens in the summer of 1940. These internees came from all
walks of life – businessmen, teachers, journalists, gardeners, students
and musicians – and inside the camp they had access to a small theatre
with a stage and piano, a cinema, an art studio and lecture room.

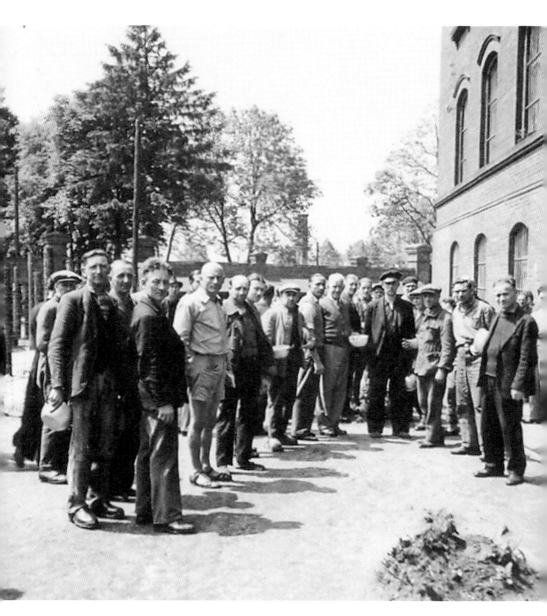

^ A group of internees in the grounds of camp Ilag VIII/H Tost, 1941. FO 916/39

Ilag VIII Tost

The question of fresh fruit for the boys under 20 years of age referred to in the two last reports has been taken up since by the I.R.C.C. but unfortunately it was impossible to find a satisfactory solution.

VII.) MEDICAL ATTENTION AND SICKNESS

German Chief Physician: Oberarzt Dr. Krusez.

British Medical Staff: Capt. A. Stallard RAMC,
Dr. A. J. Henderson,
Dr. Henry Taca (transferred from Beverloo
Lft. Ernest Pickering, Dentist,
6 recognised sanitators,
1 Sgt. NZDC)
)Dental mechanics
1 Cpl. RAMC)

1) No change in the infirmary which has been described in our previous reports.

2) On the day of visit there were 11 patients in the "Revier" suffering from heart's, chests, hypertension, angina, flues, septic knee, chronic nephritis and internal troubles; none of them is very seriously ill. 10 patients with chronic asthma are in a special ward. They were taken out of the Revier to avoid disturbances of the others by their cough-attacks and to get more fresh air.

3) Treatment is very fair and the patients are completely satisfied with the medical assistance they receive from the British physicians. 3 cases of open Tbc. have been transferred to Koenigswartha. State of health seems to be very good the sick rate lying between 1-2%.

4) The quality of bread for diets has improved. Will be checked again.

5) Daily sick parade for ambulant treatment is attended to by an average of 30 men.

6) Supply of drugs in general is sufficient. The British doctors asked for a consignment of Antityphus-vaccine to inoculate the sanitary personnel. An amount sufficient for 20 men is asked for. Besides the doctors would like to receive about 100 bottles of syrup "Famel".

7) The doctors complained that they were not free in their decision to discharge patients of the infirmary. This matter was

discussed...

▲ A report on the medical conditions at Ilag VIII/H Tost. Many of the medical staff were themselves internees, 1943. FO 916/524

VI Isle of Man Civilian Internment Camps

As in the First World War, most civilian internees in Britain were housed in camps on the Isle of Man. Escape was difficult from an island that was over 50 miles from the mainland. Camps accommodated over 30,000 German, Austrian and Italian nationals; at one point, over 80 per cent of those interned here were Jewish refugees who had fled Nazi persecution in the 1930s. Port Erin Camp was Europe's only all-female internment camp, while other camps were segregated by nationality and by social class. Hutchinson Camp was known as 'the artists' camp' due to the thriving artistic and intellectual lives of its residents.

▼ Onchan Camp on the Isle of Man consisted of requisitioned guest houses and hotels to confine internees, 1943. HO 215/302

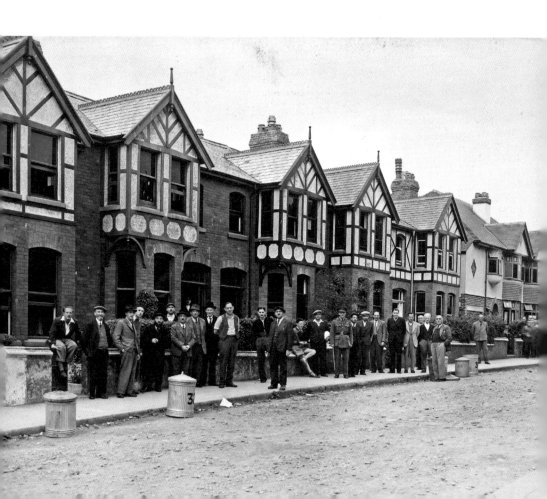

FINDING, Maria	9. 1.15	Bleiberg
FINK, Anna	9. 1.06	Gingen
FINKELDEY, Helene	15.11.07	Herne, Germany
FISCHER, Amalie	16. 8.20	Wanne-Eickel
FISCHER, Elisabeth	14. 3.01	Nonnenweier
FISCHER, Elisabeth	30. 1.12	Eberschwang
FISCHER, Marion Alice	28. 1.20	Hamburg
FISCHER, Meta	18.10.94	Lorch
FLECK, Ottilie	2.10.92	Bruchsal
FLEISCHLE, Elsa	3.12.04	Waiblingen
FLETZBERGER, Hedwig	10.10.19	St. Polten
FLISCHER, Margarete	11. 6.19	Landl
FLUCH, Maria	26. 8.90	Niederschockl
FOCKEN, Hulda Henriette Johanne	5. 9.98	Rustringen by Wilhelmshaven
FORBELSKY, Richarda Helene	22. 4.11	Vienna
FRANK, Gertrude Wilhelmine	11.11.01	Gruenendeich,Hanover.
FRANZ, Paula	1. 6.92	Barmen
FREISSEGGER, Aloisia	28. 5.14	Mühldorf Molltal
FREY, Else	29. 5.12	Argheilgen b. Darmstadt
FREY, Erika Elfriede	5. 5.19	Baden Baden
FRIEBEL, Kathe Charlotte Elfriede	26. 6.18	Berlin
FRIESE, Selma	5. 7.92	Jannowitz
FRITZ, Maria Antonia	28. 1.97	Plattling
FROEHRICH, Hedwig	22.12.09	Fellhammer
FROH, Kathe Anna Ella	1. 6.10	Schwedt
FUCHS, Maria	27. 7.96	Splitz
FUCHS, Maria Eva	11. 2.13	Vienna
FUCHS, Minna Hildegard	9.12.90	Berlin
FURCHTNER, Johanna	14. 1.05	Gerweinatal
GALLONE, Virginia	22. 8.22	Valvou, Italy
GATYARIK, Maria Doris	14. 3.00	Korneuburg/Vienna
GEISBERGER, Marie	15. 3.00	Munich
GENTNER, Lina	3.12.11	Stuttgart
GEORG, Wilhelmine	8. 7.00	Schierstein
GLOECKLE, Gertrud	19. 6.09	Goeppingen
GOLLMANN, Maria	27.10.01	Piadnitz

◀ Female German, Austrian and Italian internees housed at Port Erin Camp on the Isle of Man, 1943.
HO 215/478

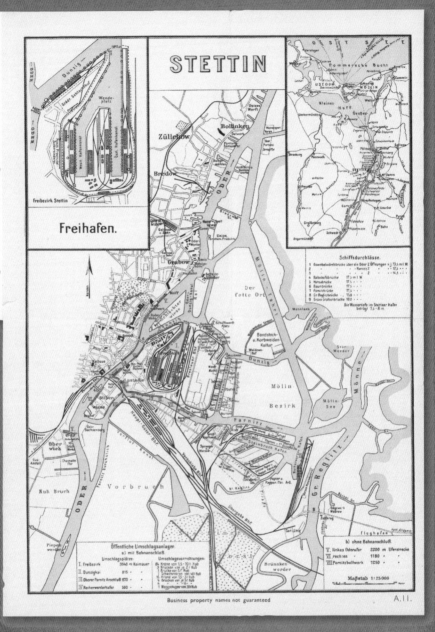

▲ Map of Stettin, a port on the Baltic, which was one of the most successful escape routes, partly thanks to a brothel frequented by Swedish sailors. WO 208 3268

2

Captives

MI5 was involved in identifying hostile enemy aliens as part of the process to assess them for internment in the UK in September 1939. After a meeting between MI5 and MI6 in December 1939, it was decided that a new arm of the intelligence service was to be formed, called MI9 (Military Intelligence Section 9). Under their director, Major Norman Crockatt, and working closely with the Air Ministry and the Admiralty, MI9's principal task was to prepare and implement plans for the escape of British POWs. MI9 supplied information needed to aid personnel in evading the enemy and in case of capture, planning and escaping from camps and prisons in enemy-occupied territories. It provided guidance and training to those who might find themselves 'behind the wire', teaching techniques for escape and evasion, as well as providing disguised equipment inside prison camps to aid in escapes.

MI9 produced a limited supply of bulletins, which were training handbooks for intelligence officers who would give instruction on evasion and escape. Much of the information was disseminated through specimen lectures given by officers; however, later lectures were delivered by selected escapees who had experienced capture and escape. During lectures marked 'MOST SECRET', no notes were allowed to be

EUROPEAN THEATRE. SECRET

Conduct if cut off from Unit or Captured by Enemy

To All Ranks, All Arms.

To be given by I.Os.

Note: The letters marked at the side e.g. (A) refer to Appx No.1 which contains possible anecdotes for appropriate inclusion in the lecture.

1. INTRODUCTION

How many of you I wonder, have thought what you would do if you were captured; if you were isolated from your own troops. What conditions would you find - what treatment would you receive - what chances have you of escaping, and if you do - how would you move about the countryside. I hope to answer these and other questions in the course of my talk.

The real answer is - DO NOT BE CAPTURED. Only at a last resort should you be in the position of being captured. Your job is to fight - and only through wounds, lack of ammunition or food should you ever allow yourself to be captured. Should you be captured, it must be your firm and constant determination to escape at the EARLIEST OPPORTUNITY - to bring back information to our people - to be a nuisance to the enemy. Every German soldier occupied in guarding you - every German soldier occupied in searching the countryside for you is one less in Germany's war machine. The man power situation there is NOT likely to improve as time goes on.

In 1939 the German authorities produced a fairly lengthy document for consumption by the German people dealing with the question of Escape in the last war. In it was pointed out to the Germans the vital part our escapes had played in bringing about the collapse of Civilian Morale. By propaganda - by taking back information to our people - by the very fact that they were abroad in the country - all these aspects had their effect. The Document warns the German people against this danger and pleads with them to resist any attempts at bribery - to stand firm in 'mutual confidence' and to do all in their power to assist in the capture of evaders and re-capture of escapers. What went for the last war goes equally well for this. Be a nuisance to the enemy - keep him 'on the hop' - sow the insidious seeds of propaganda - seek out information - YOU can help to make their collapse the more complete.

I propose to give you a General Background of the situation in Europe as it has existed up to the present - we shall then consider how this is likely to be affected on the opening of a Second Front.

2. EVASION AND ESCAPE

Evasion and Escape - what is the difference between these two. It is important. Evasion.......? You are evading capture - you have NOT been in the hands of the enemy at all - you have been cut off from your own people. Escape - you have been in the hands of the enemy - even if only for 10 minutes - and have escaped. The important point is this: as an evader - if you reach a Neutral Country you will be interned - as an escaper you will be repatriated to this country. There is then only one answer - if you are an Evader and reach a Neutral Country you must say that YOU ARE AN ESCAPER. Have a simple story ready - the simpler the better - you have been in the hands of the enemy - if only for half an hour - and escaped. Keep it simple, and if there are two of you - have the same story. The Authorities will NOT check up - they are friendly towards us. I'll deal later with the legal aspects of Evasion and Escape. (A)

3. EVASION

Let us deal with evasion first. What does it imply? It means moving about undetected by the enemy - in the occupied countries, moving about a

/contd........ countryside

> Introductory lecture 'Your Duty'. WO 208 3242

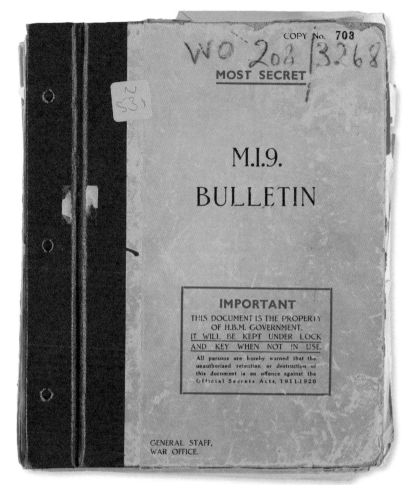

◄ *M.I.9. Bulletin* was a handbook for use by intelligence officers in the training of others in escape and evasion. It was updated whenever MI9 felt it necessary to amend or add information that was gathered from intelligence sources throughout the war.
WO 208/3268

taken unless specific instruction was given to do so, and participants were not allowed to discuss the content with anyone.

'Blood chits' were prepared in several languages, but were not for use in Europe as they were deemed to be easily forged. The chits served as a promise of a reward if an airman needed help to escape, thus overcoming the language barrier he may have encountered if forced down in enemy-occupied territory. Phrase books in several languages were issued for use in Europe.

INSTRUCTIONS

(1) Learn by heart the Russian phrase "Ya Anglicháhnin" (means "I am English" and is pronounced as spelt).

(2) Carry this folder and contents in left breast pocket.

(3) If you have time before contact with Russian troops, take out the folder and attach it (flag side outwards) to front of pocket.

(4) When spotted by Russian troops put up your hands holding the flag in one of them and call out the phrase "Ya Anglicháhnin."

(5) If you are spotted before taking action as at para 3 do **NOT** attempt to extract folder or flag. Put up your hands and call out phrase "Ya Anglicháhnin". The folder will be found when you are searched.

(6) You must understand that these recognition aids **CANNOT** be accepted by Soviet troops as proof of bona fides as they may be copied by the enemy. They should however protect you until you are cross questioned by competent officers.

F.R.1.

Я англичанин

"Ya Anglicháhnin" (Pronounced as spelt)

Пожалуйста сообщите сведения обо мне в Британскую Военную Миссию в Москве

Please communicate my particulars to British Military Mission Moscow.

⏶ Blood chit in Russian. WO 208 3242

➤ Phrase books. WO 208 3242

NOT TO BE PRODUCED IN PUBLIC

NOT TO BE PRODUCED IN PUBLIC

SPANISH

ENGLISH	SPANISH	ENGLISH	SPANISH
One	Un, Uno, Una (f)	Twenty	Veinte
Two	Dos	Thirty	Treinta
Three	Tres	Forty	Cuarenta
Four	Cuatro	Fifty	Cincuenta
Five	Cinco	Sixty	Sesenta
Six	Seis	Seventy	Setenta
Seven	Siete	Eighty	Ochenta
Eight	Ocho	Ninety	Noventa
Nine	Nueve	Hundred	Cien
Ten	Diez	Five Hundred	Quinientos
Eleven	Once	Thousand	Mil
Twelve	Doce		
Thirteen	Trece	Monday	Lunes
Fourteen	Catorce	Tuesday	Martes
Fifteen	Quince	Wednesday	Miercoles
Sixteen	Dieciseis	Thursday	Jueves
Seventeen	Diecisiete	Friday	Viernes
Eighteen	Dieciocho	Saturday	Sabado
Nineteen	Diecinueve	Sunday	Domingo
Minutes	Minutos	Week	Semana
Hours	Horas	Fortnight	Quince Dias
Day	Dia	Month	Mes
Night	Noche	O'clock	Hora

ENGLISH	SPANISH
I am (we are) British (American)	Soy Inglés (somos Ingleses), (somos Americanos)
Where am I?	Donde Estoy?
I am hungry; thirsty	Tengo Hambre; Sed
Can you hide me?	Puede Usted Esconderme?
I need civilian clothes	Necesito Traje Civil
How much do I owe you?	Cuanto le Debo?
Are the enemy nearby?	Está El Enemigo Cerca?
Where is the frontier?	Donde Queda La Frontera?
Portuguese; Belgian; French	Portuguesa, Belga, Francesa
Swiss; Spanish	Suiza, Española
Where are the nearest British (American) troops?	Cual Es El Lugar Mas Proximo Donde Hay Tropas Inglesas? (Americanas?)
Where can I cross this river?	Donde Puedo Pasar Este Rio?
Is this a safe way?	Es Este Camino Seguro?
Will you please get me a third class ticket to ...?	Sirvase Usted Conpearme Un Billete De Tercera para ...?
Is this the train (bus) for ...?	Es Este El Tren (Auto Bus) para ...?
Do I change (i.e. trains)?	Tengo Que Cambiar (DeTren)?
At what time does the train (bus) leave for ...?	A Que Hora Sale El Tren (Autobus) Para ...?
Right; left; straight on	Derecha, Izquierda, Siga Derecho
Turn back; stop	Vuelvase, Pare
Thank you; please	Gracias, Por Favor
Yes; No	Si, No
Good morning; Afternoon	Buenos Dias, Buenas Tardes
Evening; Night	Buenas Tardes, Buenas Noches
Consulate	Consulado
Out of bounds; Forbidden	Prohibido, Defendido.

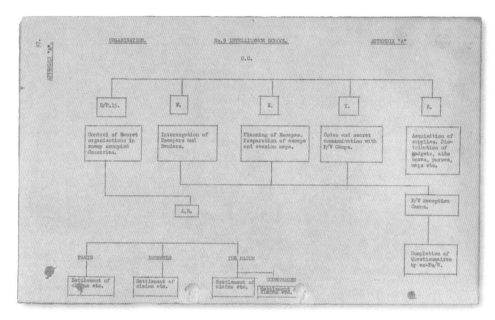

▲ Organisation of No. 9 Intelligence School showing the work of IS9 Z, the department responsible for acquiring supplies and distributing gadgets and escape aids, and IS9 W, who prepared the escape and evasion maps.
WO 208 3242

◄ Evasion and escape lecture for captives in the Far East.
AIR 23 2934

ISOLATION	Geographical point of view - desire to be isolated - language barrier.
ORIGIN	Ainu - Indonesian invaders - Chinese.
CHARACTER	Southern blood - unbalanced tendencies - outward calm - inward emotions.
FEUDALISM	The family - the clan spirit - fighting community - Warrior's code.
WORSHIP	Ancestor - Shinto, the way of the Gods. Jimmu first Emperor - descendant of Sun Goddess. Buddhism - Moulded to suit Jap way of life - overshadowed Shintoism for 1,000 years until restoration of Emperor 1868. Christianity - Fears of Spain's Imperialistic aims - eradicated 1637.
SAMURAI	Swordsmen of the Feudal Lord - Became the gentry of Japan - privileged class.
EMPEROR	His divinity - Fought for by clans - always held in reverence.
THE SHOGUN	Most powerful Feudal Lord or Diamyo - Military Dictator.
THE INDIVIDUAL	Child's surroundings - Parents dictate career. Custom and convention. Individualism crushed - Humble position of women - their affect on the male.
COMPLEXES	Superiority, a race apart - Inferiority, the Western world their teachers.
BRUTALITY	Accounted for by both complexes.

⌃ Background
to Japan.
WO 208 3242

MI9's work continually grew and expanded and so IS9 (Intelligence School 9) was formed in January 1942. It was organised into seven departments, each one having its own objectives. One of the key objectives of IS9 W section was to carry out 'interrogations' to obtain information for the lectures and for the bulletin. This enabled the bulletin to be updated with information gathered by intelligence throughout the war.

It was not until June 1945 that MI9 issued a bulletin dealing with the Far East, much of which was mostly devoted to survival in the jungle. It took almost the duration of the war to gather the intelligence necessary to provide this guidance.

II Guy Griffiths

Guy Griffiths, a Royal Marines pilot captured in the opening weeks of the war, gained notoriety as a POW in Dulag Luft and other POW camps for using his artistic skills to produce sketches of fake British aircraft that he left around the camp for guards to find, thus feeding misleading intelligence to the German authorities. Working secretly for MI9, Griffiths also gathered information about Nazi aircraft from camp officials to be clandestinely sent back to the UK.

'Generally I talked with German Officers who knew I was very keen on paintings and drawings of aircraft and who would look at my sketches. Eventually the conversation would turn towards German types of aircraft, they would let drop pieces of information. Such things as Messerschmitt 109 is a very good machine but its performance is poor high up would cause them to naturally deny it and state what the aircraft would do. At the same time, they would probably boast of a new type and possibly give some idea of its performance.'

▼ Sketch of the imaginary 'Westland Wildcat' aircraft, created by Guy Griffiths to mislead German intelligence. WO 208/5440

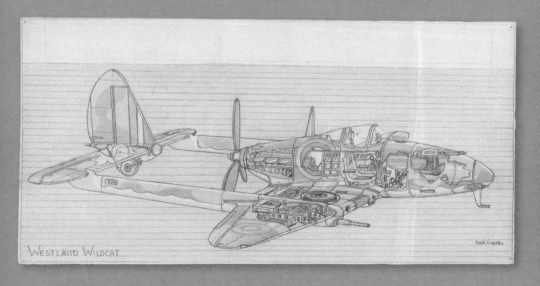

WESTLAND WILDCAT.

DO NOT DESTROY: SPOILED COPIES
ARE TO BE HANDED IN.

TOP SECRET
M.I.9/INT/SP./ **4817**
MIS-X

No. and Location of Camp(s) about __E 30 Submarine, WILHELMSHAVEN NAVAL JAIL,__
which you have special information __BRUNSWICK Camp 11, SPAGANBURG 9 A, DULAG__
__LUFT, STALAG LUFT I, STALAG LUFT III, NURENBURG STALAG LUFT III__
__MOOSBURG.__ 13.

SPECIAL QUESTIONNAIRE FOR BRITISH/AMERICAN EX-PRISONERS OF WAR.

1. No._____ Rank __Captain__ Surname __GRIFFITHS__

 Christian Names __Guy Beresford Kerr__

2. Ship (R.N., U.S.N. or Merchant Navy) __H.M.S. "ARC ROYAL"__

 Unit (Army)_____ __Royal Marines__

 Squadron (R.A.F. or A.A.F.) __803 Fleet Air Arm.__

3. Private Address __Freedom, Smugglers' Lane, BOSHAM, Sussex.__

4. Decorations _____

5. What position did you hold in the camp ? (e.g., Senior British Officer/Senior American Officer or member of Escape Committee).

Camp.	Position.	From	Till
DULAG LUFT I & 3	Intelligence Aircraft	Dec.39	
STALAG LUFT I & 3.	Information under W/Cdr.		
	DAY, Forgery, copying for		
	escape purposes under		

6. Give names of members of Escape Committee(s) in the Camp(s) in which you were imprisoned with dates when they were on the Committee.

 Camp __DULAG LUFT__ Members __S/Ldr. BUSHELL 1940-May 41. F/Lt. J.__
 __MARSHALL, F/Lt. BOARDMAN,__

 Camp __STALAG LUFT I.__ Members __S/Ldr. BUSHELL, F/Lt. MARSHALL,__
 __June 41 – April 42__

 Camp __STALAG LUFT III__ Members __S/Ldr. BUSHELL, Lt/Cdr. FANSHAWE.__
 __Lt. Cdr. BUCKLEY.__
 __STALAG LUFT III 1944 W/Cdr. J. ELLIS, D.F.C.__

7. How was the work of the Committee organised and carried out ?
 The Committee listened to any plans which were possible or reasonable.
 If the plan was organised with a fair chance of success, the officer
 concerned was equipped with papers, clothing and food necessary for his
 escape and given all information that could help him. The organisation
 had a department known as Dean & Dawson under F/Lt. WAYLEN which supplied
 all papers, passports, tickets. A mapping section supplied routes, maps

1

◄ Methods
of obtaining
information on
aircraft, taken
from Griffiths'
liberation
questionnaire,
1945.
WO 208/5440

III Peter Gardner

Peter Melville Gardner was a Spitfire pilot who bailed out over France
on 11 July 1941. After spending some time in *Oflags*, he was transferred to
Stalag Luft III in July 1942, from where he sent letters home, including
postcards and photographs that contained secret messages hidden
between the image and the backing paper. Gardner was discovered and
his materials were confiscated.

A hidden message sent by Peter Gardner from Stalag Luft III

'Escape organisation forgery dept. Had marked success with various documents supplied to number of escapees on 5 March, but have considerable difficulty obtaining originals to copy. Therefore request tracing of: identity card for foreign workers in Germany. Leave pass ditto. Suggest suitable paper as fly leaves in books. Request also powdered Indian ink, three very fine mapping nibs.'

One of Flight Lieutenant Gardner's letters to his mother which accompanied the hidden message

'Do you remember Guy Griffiths at school. I haven't seen him for ages, it's extraordinary meeting him here. He has been down over 2 years and looks fitter than ever. I am enclosing this photo of him, which I think will show you that we are looked after O.K. The weather is glorious here and this place looks just like Blackpool Beach on a Bank Holiday. An absolute sea of brown bodies …'

◀ A hidden message on tissue paper sent by Peter Gardner from Stalag Luft III, by means of concealing it as a postcard with a photograph of Guy Griffiths. AIR 40/2622

➤ AIR 40/2622

▲ ▼ A photograph of airmen at dinner and the concealed message (below) which was hidden within it. AIR 40/2622

[handwritten top right] F/L ER SHORE.
20 Jan 43
Oflag XXI B, Poland

TRANSCRIPT OF CONCEALED MESSAGE

[handwritten left margin] DDMI P/W. M.I.19 P.H.26) ETD. USA. (Cr Col Mac)

 Rations received (Shubin (Altburgund) (?)) between 7 Sept to 27 Dec 1942 inclusive per man per 4 weeks, periods in grammes: MEAT fresh 800, 900, 1000, 1000. Sausage 400 each period. Potatoes 14900, 19050, 20400, 20400. Bread 8000, 8500, 9000, 9000. PRESERVES Jam 300, 300, 275, 300. Kunsthonig 400, each period. Sugar 700 each period. FATS Margarine 300, 450, 290, 600. Cooking 524, 374, 554, 224. Cheese 186, (73) 186.9, 187.2. Cereals 600, 450, 325, 250. * Fresh meat & sausage obtained from local abattoir & cold storage plant situated near station. Cattle killed black & white poor quality unfattened. Pork issued short time in Sept. Oct. again between 24 to 27 Dec. Winter ration fresh meat W.E.F. 19 Oct. Vegetables obtained locally turnips, carrots, cabbage. Sauerkraut manufactured in camp. Potatoes ration increased 12 Oct on arrival new consignment. Bread Winter ration W.E.F. 19 Oct. Bakery at Gneisen approx. 60 Km staffed by Polish civilians, supervised by German Army officers. Bread arrives here by rail. Treacle sometimes substituted for Kunsthonig. K.Honig marked D.G (?) & B.G. Witt. Nahrmittelfabrik, Adolf Hitlerstr. 30 Kitzmannstadt (or Witzmannstadt?). Margarine marked Amada A.G. Danzig. W/T INSTALLATION for information, An all wave OV1 set constructed & in use. Listen into 1300 & 1500 GMT Indian Service being only satisfactory news found to date. Difficulties are: (1) heavy QRM (2) DC Mains variation (3) Current switched off irregular periods (4) Prowling Germans therefore require at least 3 transmissions before certain reception of a message. * ESCAPOLOGISTS require green dye for construction of German Army uniforms. * GERMAN INSPECTION OF PARCELS. This camp comparatively strict improbable it will slacken appreciably. Food tins opened & sometimes prodded, especially tins from individually addressed parcels from to private persons. Tobacco tins opened but not prodded for only superficially. Arrangements can be insulted (sic) to extract the necessary article.

[handwritten left margin] P/19/34

[handwritten] Inspected. However with prior information

[handwritten bottom left] see over

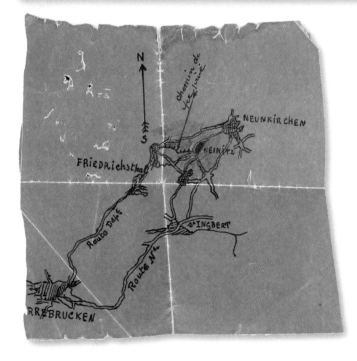

˄ A section of the decoded message copied to IS9 (X), who were tasked with preparing escape and evasion maps. AIR 40/2622

˂ A tiny map carried by Captain George Tsoucas during his escape from Stalag VII Moosburg which was handed to MI9. AIR 40/2622

IV Peter Butterworth

Having been shot down over Holland in 1941, Peter Butterworth found himself in a number of POW camps, eventually spending most of his time in Stalag Luft III. Here he honed his skills as an actor (featuring in the *Carry On* films after the war), while also taking an active role in set decoration at the camp's theatre. He was also noted as having a key role during the 'Great Escape' from the camp in March 1944.

▲ First page of German POW card for Peter Butterworth. WO 416/53/114

Gefangenenlager: | Staatsangehörigkeit: | Nr. der Liste:
Gefangenen-Nr.: *Stalg Luft II (623)* | *England* | Seite der Liste:
Name: *Butterworth* | Beruf:
Vornamen: *Peter* | Religion:
| Dienstgrad: *Ob. Leutn.*
Geburtstag u. Geburtsort: *4. 2. 15* | Truppenteil:
Bramhall.
Vorname des Vaters: | Komp. ufw. Matr. Nr.
Familienname der Mutter: | Ort und Tag der Gefangennahme oder Internierung:
| Verwundungen, Verletzungen oder Tod:
Name u. Anschrift der zu benachrichtigenden Person: | wann und von wo zugegangen:
Aufenthalt u. Veränderungen: *7. 6. 41. v. Stalag Luft I. n. Stalag Luft II. / Ste. 18. 7. 1. Stalag Luft I.*
8. 6. 41. 1. a. Ste. 73. 7. 2. Stalag Luft II.
11. 4. 42 v. Stalg Luft I u. Stalg Luft III. 1. Sch. 3 S. 3 Stalg Luft III. f. auch Sch. 1635 Stlg Luft
V 5

(a) Code letter writers

The following are the personnel in this Camp from whom messages were received by I.S.9.:-

28104	S/Ldr.	R. R.	ABRAHAM,	R.A.F.
40197	W/Ldr.	P. S. G.	AID ERSEN,	R.A.F.
37078	F/Lt.	D.	BARRETT,	R.A.F.
10056	F/Lt.	W.	BARRETT,	R.A.F.
77925	S/Ldr.	G. G.	BASTIAN,	R.A.F.
79225	F/Lt.	R. G. M.	BOND,	R.A.F.
47002	F/Lt.	H. J. W.	BOWDEN,	R.A.F.
-	Lt.(A)	H. R.	BRACKEN,	R.N.
33305	F/Lt.	J. C.	BREESE,	R.A.F.
78530	F/Lt.	J. R. S.	BROCKWAY,	R.A.F.
87664	F/Lt.	J. L.	BROMLEY,	R.A.F.
41899	F/Lt.	I. M. R.	BROWNLIE,	R.A.F.
37275	S/Ldr.	R.	BUDDEN,	R.A.F.
43932	F/Lt.	L. G.	BULL,	R.A.F.
74666	F/Lt.	J. C. W.	BUSHELL,	R.A.F.
90120	W/Ldr.	R. J.	BUSHELL,	R.A.F.
-	Lt.(A)	P. W. S.	BUTTERWORTH,	R.N.
57595	F/Lt.	V. G.	BURNS,	R.A.F.
44879	S/Ldr.	C. N. S.	CAMPBELL,	R.A.F.
69467	F/Lt.	R. G.	CARROLL,	R.A.F.
68794	F/Lt.	M. F.	CARSON,	R.A.F.
-	Lt.Cdr.(A)	J.	CASSON,	R.N.
41255	F/Lt.	R. S. A.	CHURCHILL,	R.A.F.
44687	F/Lt.	J. P.	CLAYTON,	R.A.F.
-	Lt.(A)	G. A.	CORRI,	R.N.
108572	P/Lt.	L. D.	COX,	R.A.F.

/90285

∧ German POW Card for Peter Butterworth showing the different camps in which he was held during his time in captivity. WO 416/53/114

< A list of code-letter writers in Stalag Luft III Sagan naming Peter Butterworth and Roger Bushell. WO 208/3283

V Michael Sinclair

Having earned a reputation as a serial escaper, Michael Sinclair was
sent to Colditz. It was there, in May 1943, that Sinclair tried his most
audacious attempt yet: dressing as a German guard, complete with
uniform and fake moustache. The escape failed, as he was shot at close
range by one of the other guards, but this did not put him off. Sinclair
made his final attempt in September 1944, which resulted in his death
as he attempted to scale the castle fence.

∧ German POW card for Michael Sinclair. WO 416/330/232

VI Kalyan Singh Gupta

Captured in Malaya shortly before its capitulation, Kalyan Singh Gupta was subjected to torture and harsh treatment by his Japanese captors because he repeatedly refused to join the Indian National Army, which was formed to fight alongside the Japanese against Allied forces. Signing up to the Indian National Army would have resulted in escape from his POW camp, but as a veteran of the British Indian Army, having served for over twenty years prior to his imprisonment, Gupta refused to forget the oath of allegiance he had sworn to the British Crown. He was awarded an MBE after the war for what he had endured.

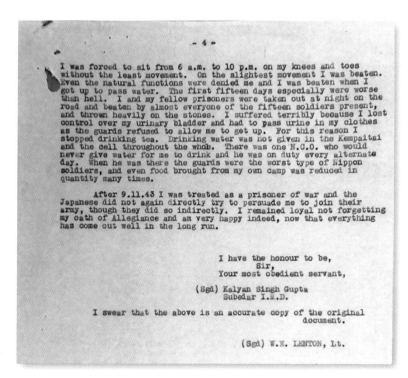

- 4 -

I was forced to sit from 6 a.m. to 10 p.m. on my knees and toes without the least movement. On the slightest movement I was beaten. Even the natural functions were denied me and I was beaten when I got up to pass water. The first fifteen days especially were worse than hell. I and my fellow prisoners were taken out at night on the road and beaten by almost everyone of the fifteen soldiers present, and thrown heavily on the stones. I suffered terribly because I lost control over my urinary bladder and had to pass urine in my clothes as the guards refused to allow me to get up. For this reason I stopped drinking tea. Drinking water was not given in the Kempaitai and the cell throughout the whole. There was one N.C.O. who would never give water for me to drink and he was on duty every alternate day. When he was there the guards were the worst type of Nippon soldiers, and even food brought from my own camp was reduced in quantity many times.

After 9.11.43 I was treated as a prisoner of war and the Japanese did not again directly try to persuade me to join their army, though they did so indirectly. I remained loyal not forgetting my oath of Allegiance and am very happy indeed, now that everything has come out well in the long run.

I have the honour to be,
Sir,
Your most obedient servant,

(Sgd) Kalyan Singh Gupta
Subedar I.M.D.

I swear that the above is an accurate copy of the original document.

(Sgd) W.E. LENTON, Lt.

◄ Last page of the testimony Kalyan Singh Gupta gave about his treatment during his time as a POW, 1945. WO 325/39

VII Margarete Klopfleisch

Margarete was a Jewish refugee from Germany who arrived in the UK in 1939 with her husband, Peter. Klopfleisch, a student of art and sculpture, was initially exempt from internment following a tribunal on 27 November 1939. However, in May 1940, after the fall of France and due to fears of enemy invasion, that decision was reversed and she was interned on the Isle of Man. After being separated from her husband, who was deported to Australia on HMT *Dunera*, Klopfleisch sadly suffered a miscarriage at the camp in July 1940. She was released on 20 May 1941.

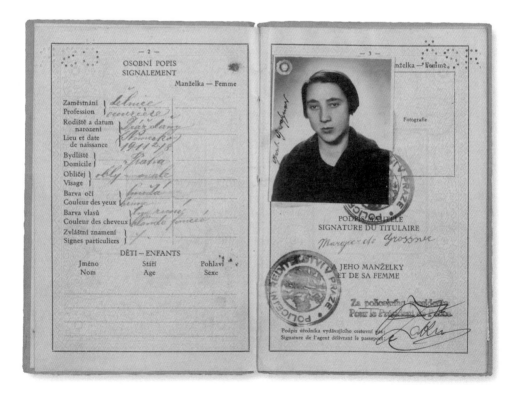

▲ Margarete Klopfleisch's passport. She would have used this when she landed in London on 9 March 1939 as a refugee. HO 405/29247

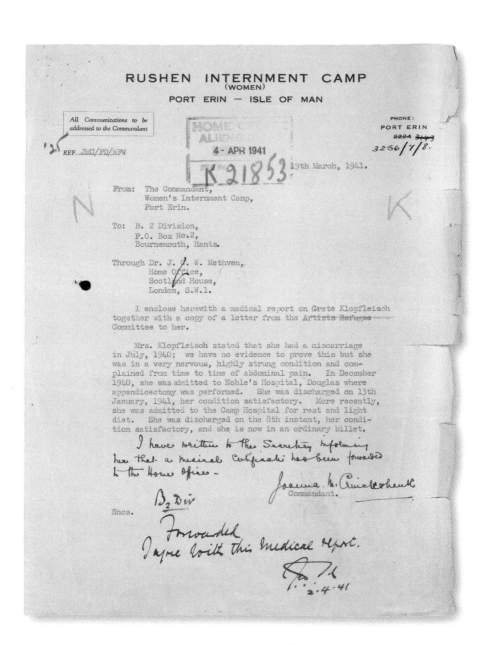

RUSHEN INTERNMENT CAMP
(WOMEN)
PORT ERIN — ISLE OF MAN

All Communications to be
addressed to the Commandant

REF...JMC/FD/MFW

HOME
ALIENS
4 - APR 1941

K 21853

PHONE:
PORT ERIN
2224
3256/7/8.

19th March, 1941.

From: The Commandant,
Women's Internment Camp,
Port Erin.

To: B. 2 Division,
P.O. Box No.2,
Bournemouth, Hants.

Through Dr. J. G. W. Methven,
Home Office,
Scotland House,
London, S.W.1.

I enclose herewith a medical report on Grete Klopfleisch
together with a copy of a letter from the Artists Refugee
Committee to her.

Mrs. Klopfleisch stated that she had a miscarriage
in July, 1940; we have no evidence to prove this but she
was in a very nervous, highly strung condition and com-
plained from time to time of abdominal pain. In December
1940, she was admitted to Noble's Hospital, Douglas where
appendicectomy was performed. She was discharged on 13th
January, 1941, her condition satisfactory. More recently,
she was admitted to the Camp Hospital for rest and light
diet. She was discharged on the 8th instant, her condi-
tion satisfactory, and she is now in an ordinary billet.

*I have written to the Secretary informing
her that a medical Certificate has been forwarded
to the Home Office -*

Joanna M. Cruickshank
Commandant.

Encs.

B₂ Div

*Forwarded
I agree with this Medical Report.*

2.4.41

∧ Letter detailing medical information relating to Margarete Klopfleisch at Port Erin Camp
on the Isle of Man. HO 405/29247

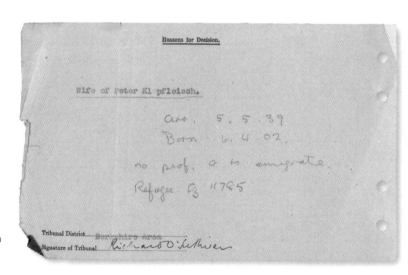

FEMALE ENEMY ALIEN—EXEMPTION FROM INTERNMENT—REFUGEE

(1) Surname (*block capitals*) ___ KLOPFLEISCH,

Forenames ___ Marketa.

Alias ___

(2) Date and place of birth ___ 2/8/1911 in Dresden.

(3) Nationality ___ German

(4) Police Regn. Cert. No. ___ 715315

Home Office reference, if known ___

Special Procedure Card Number, if known ___

(5) Address ___ Bray Court, Bray, Berks.

(6) Normal occupation ___ Domestic.

(7) Present Occupation ___ Housewife.

(8) Name and address of employer ___

THE HOLDER OF THIS CERTIFICATE IS TO BE EXEMPTED
UNTIL FURTHER ORDER FROM INTERNMENT.

(9) Decision of Tribunal ___ Date 27/11/39

(10) Whether exempted from Articles 6 (*a*) and 9 (*a*) (Yes or No) ___ No

(11) Whether desires to be repatriated (Yes or No) ___ No

25m 9/39—[7815] 34361/893 50m 11/39 4070 G & S 704

[OVER

▲ Alien internment tribunal card for Klopfleisch. HO 396/181

Reasons for Decision.

Wife of Peter Klopfleisch.

arr. 5.5.39
Born 6.4.02.
no prof. a to emigrate.
Refugee G 11785

➤ The reverse of Margarete's Alien Registration card. HO 396/181

Tribunal District ___ Berkshire Area

Signature of Tribunal ___ Richard O'Sullivan

VIII P.G. Wodehouse

British author and playwright P.G. Wodehouse was arrested as an 'enemy alien' in Le Touquet, France, on 21 July 1940. Like hundreds of others, he was transferred to Ilag VIII/H Tost civilian internment camp in Upper Silesia.

Writing was vital for him. During his internment he kept diaries, produced articles and worked on two novels, including *Money in the Bank*, which was published in January 1942. Wodehouse was released from Tost in 1941 and later, while living in Germany, made broadcasts to US audiences over German radio, which prompted anger and accusations of treachery in Britain. He later wrote to a friend that 'it was a loony thing to do'.

▼ Wodehouse's internee card. His name is spelt incorrectly but accurately records him as a writer ('*schriftsteller*') and spectacle-wearer ('*brillentrager*'). WO 416/398/363

IX Peter Stadlen

Austrian national Peter Karl Theodor Stadlen was a Jewish refugee who came to the UK before the outbreak of the war. Initially assessed as Category C (of no threat to national security), he was arrested in May 1940 following the fall of France and deported to Australia on HMT *Dunera*, departing Liverpool on 10 June.

Stadlen was a phenomenal concert pianist and had been performing in the Netherlands as late as 1938 before moving to the UK. His talent caught the attention of British composer Ralph Vaughan Williams and he, with others, wrote to the Home Secretary asking for Stadlen's immediate release from Hay Camp in Australia. When he was finally let out in October 1941, Vaughan Williams suggested that, rather than face the perilous journey back to the UK, he should remain in Australia and be allowed to work there. In the end, Stadlen did make his way back to the UK, and he and Vaughan Williams met up. After the war, he became a music critic for the *Daily Telegraph* before retiring in 1985. He died in London eleven years later.

➤ Stadlen's portrait on the front of publicity for a piano concerto in the UK, 1939.
HO 405/47431

PETER
STADLEN

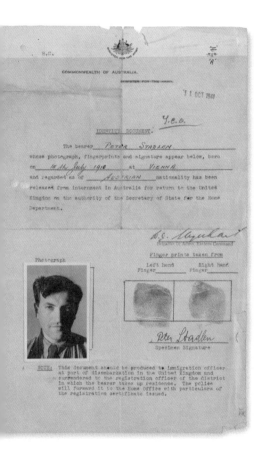

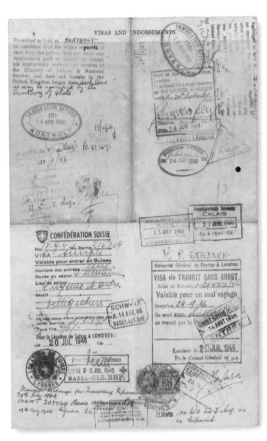

▲ Stadlen's release from internment at Hay Camp, New South Wales, Australia, 11 October 1941. HO 405/47431

▲ Stadlen's passport detailing his journey from Austria to the Netherlands and then to the UK as he fled Nazi persecution. HO 405/47431

➤ British
composer
Ralph Vaughan
Williams's plea
to allow Stadlen
to be freed
and to remain
in Australia to
perform as a
classical pianist.
HO 405/47431

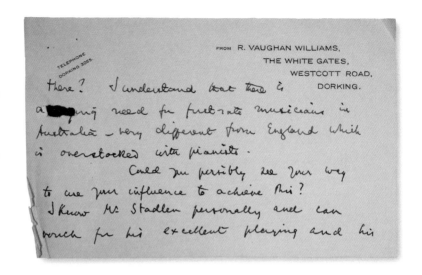

There ? ✓ understand that there is
a [illegible] need for first rate musicians in
Australia — very different from England which
is overstocked with pianists.
 Could you possibly see your way
to use your influence to achieve this?
I know Mr Stadlen personally and can
vouch for his excellent playing and his

FROM R. VAUGHAN WILLIAMS,
THE WHITE GATES,
WESTCOTT ROAD,
DORKING.

X Gladys Skillett

Gladys Skillett, a 24-year-old nurse, was one of over 800 people from
Guernsey who were deported to Germany in September 1942. In total,
nearly 2,300 British citizens not born on the islands were deported, many
with their families. This was a direct order from Hitler in retaliation for
internment of German citizens in Persia by the British Government.

Skillett was deported with her London-born husband, Sydney, and
young son, Colin. However, she was separated from her husband and
sent with Colin to a camp in Lindele, where she gave birth to another
son, David, in a nearby hospital. There, in the maternity ward, despite
being on opposite sides of the war and not speaking German, she
befriended local German woman Maria Koch, who was also pregnant.
Initially, they were often only able to communicate through the wire
fences surrounding the camp, but they formed a strong bond and
friendship that endured after the war.

No.	Name	Geburtstag und -ort	Naechster Verwandter	Beruf	letzter Wohnsitz	Tag der Festnahme
115	CHINN Jessie	11.Nov.1895 Leeds	Mrs. Deans,22 Pier son Road,Jersey	Hausfrau	Jersey	Jersey 18/9/42
116	▓▓▓	▓▓▓▓	▓	▓▓▓▓	▓	▓
117	CHINN Robert	26. Mai 1902 Cairo	Chinn, Peel Road Jersey	- - -	"	"
118	CHINN Robert	14.Aug.1928 St.Saviours,Jersey	"	Schueler	"	19/9/42 Jersey
119	CHURCHILL Edward G.	5.Okt.1904 Yevoil	Mr.Churchill, 5 Victoria Rd. Yeovil,Somerset	Verkaeufer	"	Jersey 16/9/42
120	CLEMENT Mabel	8. April 1913 Chicago	Mrs.West,2 Rose Terrace,Hedley Hill Colliery Worham	Kranken- schwester	"	"
121	CLEMENT Walter	5. April 1916 Spennjmor	Mrs.Clement 26 Dene Terrace, Chilton	Apotheker	"	"
22	COLLES Adelaide H.	20.Febr.1890 Camaru,New Zeald.	42 Houst, Camaru, New Zealand	- - -	"	Jersey 19/9/42
23	COMBER Alan B.	17.Juli 1879 Holesworthy	Dorothy Ekins Lymestone nr.Exeter	- - -	"	"
24	CONSTABLE Emma J.	16.Juli 1890 St.Helier	Mr.Touzel, Castle View,Trinity	- - -	"	Jersey 18/9/42
25	CONSTABLE Frederick	26.April1891 Tonbridge	Thorn, Earne, Exeter	Arbeiter	Jersey	Jersey 19/9/42
26	COOPER Eva D,	16.April 1901 Jersey	3 The Pebbles Marett Rd.Jersey	Kaufmann	"	Jersey 18/9/42
27	COWAN Walter	27.Juli 1875 Aberdeen	William Cowan Heathlsa, Red House Jersey	Verkaeufer	"	"
28	CRACKWELL Daisy M.	21.Nov.1882 St.Heliers	16 Thenfenet Street Partwerighte Gardens London	Haus- frau	"	"
29	CRACKWELL William A.	22.Aug.1878 Ipswich	I.de St.Cader 16 Cartwright Gardens, Thonet Street	- - -	"	"
30	CRAIG Jenny Jenny	24. Juni 1884 Jonstone	Captain Thomas Stevenson Craig Royal Tank Regiment Seventh Battalion	Hausfrau	"	"
31	CRAIG Thomas	24. Maerz 1877 Manchester	"	- - -	"	"

◀ List of some of the people who were deported from the Channel Islands to camps in Germany. HO 144/22920

◀ Gladys Skillet's details entered into the German POW camp's records.

you that the crater was made by a large unexploded bomb.

Remembering the incident I quoted at the beginning of this article, the situation might have had a sticky ending, but fortunately, by sheer good luck, no one was hurt.

This is, however, not good enough: we must have good judgment as well as good luck. Get to know the points to look for, and try to become " bomb-educated "; when you have achieved that, you will be an asset to your unit and a help to BD companies.

Name, Rank
and Number

TELL them only your name, rank and number! It's an old, old order, the sense of which has been proved over and over again. Here's another story to prove the wisdom of the advice. It's a tale about the tricks which were used by the enemy in an attempt to get information from a Royal Air Force prisoner-of-war.

List of Personnel

A sergeant who had been captured was asked if he would like to go to a camp where he had friends, and a list of personnel was read out to him, for him to indicate those he knew. His squadron leader, who was still in England, was included in the list. On the day he left the transit camp he was told that a " squadron leader had asked for all RAF personnel to report to him." He was taken to an office away from the German quarters,

where he was greeted cheerily in an Oxford accent by an officer in squadron leader's uniform. This man asked him normal questions of how he had been treated and expressed the hope that he had divulged nothing. He then produced a notebook, in which he said he was making records for the Air Ministry, and asked all kinds of questions concerning prisoner-of-war's squadron. When the sergeant refused to answer he was threatened with a charge on returning home for disobeying a senior officer, and was finally dismissed with curses.

May Try it Out

This isn't the sort of trick that Jerry will reserve for RAF captives. He may try it out on Army prisoners anytime anywhere.

Remember then : Name, rank and number only.

3

Life Inside

| In Captivity

Although the everyday life of captives differed depending on whether someone was an internee or a POW – or, indeed, where they were located around the world – there were some shared experiences. They all lost their freedom, as they were held in camps often surrounded by barbed wire with watchtowers and armed guards. They all lacked many comforts and were often undernourished. Without access to radio or newspapers, most prisoners lived in a vacuum, divorced from what was happening in the outside world. One of the hardest things was not knowing when the war and, in turn, their captivity, would end.

Life behind the wire could be a boring, dangerous and frightening existence. Out of the hundreds of thousands held captive, some tried to physically break out; relatively few succeeded, or even attempted it, and so most had to find their escape through other means.

The laws governing the treatment of prisoners stipulated that their physical and mental wellbeing had to be catered for by their captors. Prisoners were also permitted to work in certain circumstances: in Europe, Allied prisoners were often put to work in mines and factories; but, infamously, those in the Far East were subjected to forced labour on the construction of the 258 miles of the Thai–Burma railway.

3. **MORALE:**
Morale is good. The main reasons for the satisfactory state of morale are sympathetic treatment by the Commandant, speedy repatriation and friendly relations with the civilians. The camp is favourably situated in the centre of the industrial Midlands where the population is particularly friendly towards PW's. Many X-mas invitations had a good influence on morale. The fact that about 50% of the men are at present unemployed, has a bad effect on morale. The unsuitable British NCO at Altcar is responsible for lower morale in this Hostel.

4. **POLITICAL COMPLEXION:**
The failure of the 4 power conference in London and the continuence of the economic crisis in Germany have lead to a setback of political progress. The majority of the Ps/W does not believe any longer in the goodwill and sincerity of the occupying powers to help with the rebuilding of Germany. They are convinced that not only the Russians but the Western powers as well profit by the occupation of Germany. Dismantling of factories, confiscation of all industrial patents, cheap exports(timber,coal scrap iron etc.) are mentioned as examples. Political complexion is decisively influenced by news from Germany and letters from the Britsh Zone do not seem to reflect pro-British sentiments.

5. **YOUTH:**
About 25% are under 24 years old. 12 Ps/W have been to the Youth Camp. Youth organisations have been successfully contacted (details under 6).

6. **OUTSIDE CONTACTS:**
The British staff is very helpful.
a) Lowton Boys Club: 8 men attend weekly discussion groups
b) Comradeship,Wigan: formed by various religious organisations.Ps/W are invited to attend meetings twice weekly.
c) Wigan Technical and Mining College: 5 men attend courses regularly.
d) Evening Classes Ashton: English and Commercial correspondence courses.
e) Wigan Police Court: Ps/W are allowed to attend.
f) Grammar School Upholland: 3 men visited the school and took part in a Brains Trust to answer questions by teachers and pupils.
g) Conservative Youth Club,Wigan: Contacts have now been established.
h) Approved School Newton-le-Willows:30 men visited the School recently and saw the film: Children on trial. The Headmaster,Mr.Vardy, has given an open invitation to all Ps/W at 50 camp,
i) YMCA Canteens and Clubs: are open to Ps/W at Wigan,Ashton,Earlstown.
k) Methodist Churches and Youth Clubs Ashton and Haydock: Service and social evenings are attended regularly.
Bury: Members of the Society of Friends and Toc-H,Radcliffe and Manchester, visit the camp weekly. They introduce councillors,teachers etc., who lecture on 'Far East','Civil Law','Religious Problems' and other subjects,WEA-lectures at Bury and Prestwich are attended.
A Bury industrialist has allotted 20 tickets for every important concert in Lancs to Bury Hostel.
Penketh: Town Council Widnes: Ps/W attend meetings.
Musical organisations from Widnes visit the Hostel.

7.**TRAINING CENTRE:**
3 men are at the present TC-course. 12 men have already been to the TC. Though only a few are very active, all are of good influence in the camp. 5 more Ps/W have now been selected.

8. **RE-EDUCATIONAL ACTIVITIES:**
Fairly satisfactory.
Lectures: 3 lectures have been given since 20. Oct., all 3 were popular. Prof.Leibholz's lecture was particularly successful.He and Mr. Menne are wanted again.Interest in lectures depends exclusively on the personality of the lecturer.Apart from the 3 F.O.lecturers, Frau Kraemer,a civilian student from the TC, and Juvenile Court-Judge in Germany,spoke in this camp and great interest was shown in herlecture. She introduced the camp to Mr.Vardy,headmaster of the Approved School at Newton.
Discussion Groups: No interest.

> Inspection report for No. 50 Working Camp for German POWs, Ashton-in-Makerfield, Lancashire, January 1948.
FO 939/132

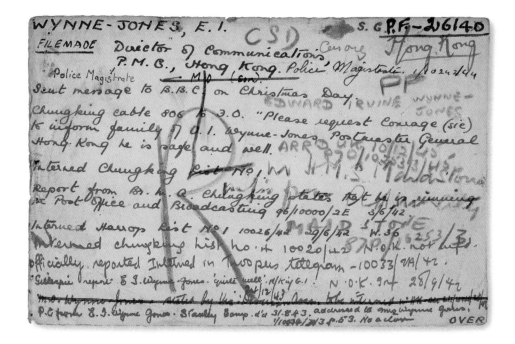

In the UK, German and Italian POWs were used extensively for labour, especially in agriculture, but their working conditions did not vary too far from those of British labourers. When not working, some Axis POWs were subject to lectures aimed at de-Nazification. Camps under British authority provided several ways for prisoners to entertain themselves and, on rare occasions, such as at Christmas, prisoners were accepted into the homes of local people. Many stayed in the UK until 1948, due to labour shortages, and were increasingly permitted to interact with the local population.

As Japan did not ratify the Geneva Convention, POWs in the Far East were not protected in the same way as their counterparts in Europe. Food was generally scarce, medical provisions in short supply and guards regularly handed out harsh punishments. The tropical conditions meant that diseases were common and death a frequent occurrence, especially for those sent out to work in often dangerous conditions. It is estimated that over 30,000 prisoners in Japanese hands died because of this

⋏ Civilian internment card for Edward Irvine Wynne-Jones. Information was pieced together on these cards from letters and correspondence received by British authorities. Before the war, Wynne-Jones was the Postmaster General in Hong Kong, information that was also noted on the card. CO 1070/4/229

treatment, a figure seven times higher than for those held in Europe. Most significantly, Japanese authorities were reluctant to pass on Red Cross supplies of food and medicine to those in need. As they denied the possibility of surrender to its own troops, it also viewed the effort spent on POWs as a 'one-way burden'; rations were often low and, if required to work, treatment was often harsh.

For Allied civilians in the Far East, food was also in short supply, overcrowding and disease were common, accommodation was inadequate and conditions were generally severe. This resulted in the deaths of over 14,000 men, women and children before their liberation in the summer of 1945.

II Entertainment

For POWs in Europe, whose wellbeing was protected by the Geneva Convention, a range of activities were available to help crush the boredom of everyday life, and provided welcome relief to those other ranks required to work for much of their time in captivity. Those in captivity constantly requested books and games, as well as sporting and other recreational equipment, to be sent to the camps; this was often organised by the Red Cross and other voluntary organisations such as the YMCA. Theatre performances were a popular activity, for both prisoners and guards, and could take up enormous amounts of free time. This was not just the case for the actors in these performances – elaborate sets could be produced, and costumes designed and made, often using what was available within the camp, or by trading with the camp guards.

In Southeast Asia, activities to alleviate boredom were often not allowed and had to be done in secret. Nevertheless, theatre and musical performances were common, while education could play an important part for adult prisoners and especially for those children in captivity. As with POWs in the Far East, contact with the outside world was minimal for internees. Many women were occupied with their domestic duties, including looking after the children interned with them. They often ran schools, bringing a semblance of normality.

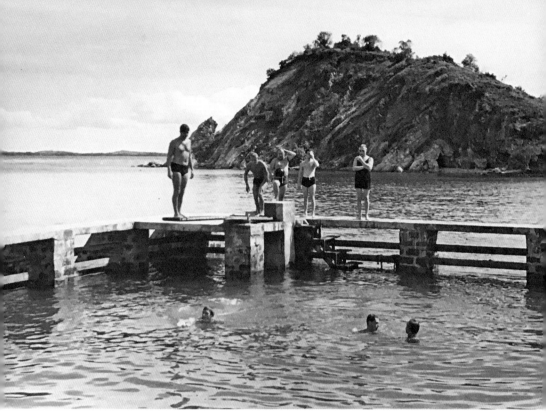

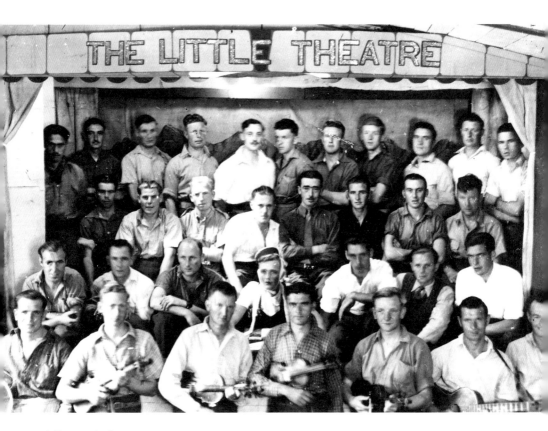

Those interned in the UK also benefited from theatres and cinemas set up on the Isle of Man camps. Each camp also produced its own magazine to promote interest and engagement in activities ranging from art and literature to sport and recreation.

III Theatre

Those in charge of camps often viewed theatre performances positively as they kept POWs and internees occupied. Though performances early on in the war were fairly rudimentary, as the war progressed their

chant Navy Theatre 5th August 1942

To From Controlling Body
Representative of of Merchant Navy Theatricals
The International Red Cross
 Geneva.

 Report on activities of Merchant Navy Theatre, Marlag
und Milag Nord.

 Since the combining of the three Theatre Parties of
Milag, Ilag (Stalag X B), Marlag Merchant Navy (Stalag X B)
in February of this year; a full and varied programme has been
carried out.

 Mr Henry Mollison's professional advice and great
stage experience in cooperation with the amateur producers have
resulted in a variety and standard of entertainment, which I feel
sure is comparable with any other Prisoner of War Camp.

 The German Authorities have always been most obliging
in assisting us in every way.

 The following productions have been staged.

"Snow White & the Seven Twerps" Pantomime
 Produced by H.Mollison Run 11 nights

"To-night's the night" Musical Farce
 Written and Produced by H.Cousens Run 10 nights

"Private Lives" by Noel Coward Straight Play
 Produced by H.Mollison Run 7 nights

"Spotlights of London" Musical Revue
 Written and produced by C.Mann Run 14 nights
 & P.Williams

("Jimmy Valentine" Crook Drama
("Vagabond King" Adaption from Musical Comedy
 Run 12 nights

 In addition to these major productions, programmes of
light classical music, variety, have been given at various
intervals between these shows.

 A large consignment of musical instruments from B.R.C.
was received in April, shared with the Royal Navy, have been, of
invaluable assistance to us. All members of the Camp wish to
express their gratitude and thanks for this generous gift.
We also wish to thank you for various supplies of music received.

 We have two orchestras,one under the direction of
Fred Goodman,the other by S.Phillips.

 Mr F.Goodman band plays with two combinations
1)Piano, four violins, three trumpets, one trombone, one cello,
 one double bass & drums.
2)Piano, two violins, two alto-Sax, one tenor Sax, three trumpets,
 one trombone and drums.

 Both combinations introducing clarinets as required.
In this orchestra are six professional musicians including
Mr Goodman, all members of crew of s/s "Arema".

◀ Extract from a Red Cross report from Marlag and Milag Camp, providing details of the various plays performed at the Merchant Navy Theatre, August 1942. WO 224/101

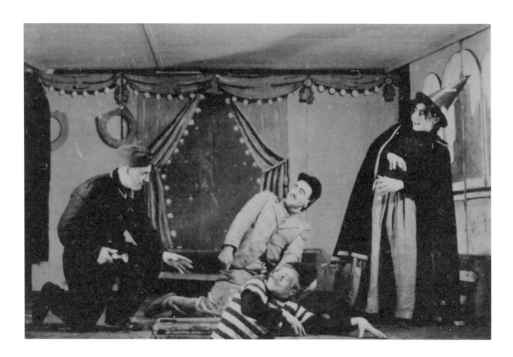

▲ Officers on stage, including Peter Butterworth, during the production of *Cinderella* at Stalag Luft I, 1941. AIR 40/287

production became more and more sophisticated, especially in the larger camps. As well as costumes and set design, these productions also required music, lighting and, of course, an enthusiastic audience. Occasionally, too, these performances could act as useful cover for escape activities.

▲ Photograph of a table tennis match at Arbeitskommando 11072 (attached to Stalag XVIIIA). WO 361/1875

IV Sport

As well as alleviating boredom for those participating or watching, sport helped keep POWs and internees fit. Football was by far the most popular sport, partly because so little equipment and space was required to play it, but a range of other sports, including cricket, boxing, rugby and, in the winter, ice hockey, were played by POWs and internees. In bigger camps, they could draw huge audiences; though, at times when rations were in short supply, especially for those POWs and internees held on mainland Europe, less sport was played than usual.

⌃ Internees
playing football
at Onchan
Internment Camp,
Isle of Man, 1943.
HO 215/302

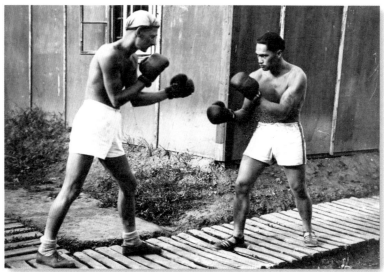

➤ Photograph
of two POW
boxers at
Arbeitskommando
11072 (attached
to Stalag XVIIIA)
shortly after
liberation,
May 1945.
WO 361/1875

V Education and Camp Industries

Most camps had education facilities and industries to help develop skills and understanding, as well as to combat the tedium. Children as well as women were interned at Port Erin Camp on the Isle of Man, so it had a functioning school. Also on the Isle of Man, internees were involved in agricultural work to help provide food. Many industries were set up in camps themselves, including bakeries, barbers, cobblers and dressmakers.

▼ Relief dressmaking class at Port Erin Women's Camp on the Isle of Man, 1943. HO 213/1053

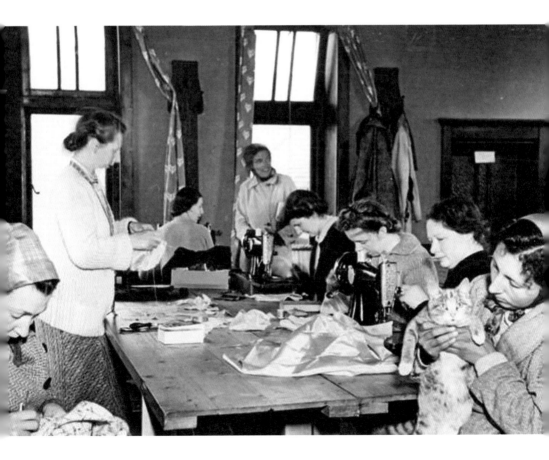

British citizen Leonard Orpin was born in 1889. A gardener by occupation, he was captured on 14 July 1940 at Vimy, Pas-de-Calais, France. Like a number of internees, he had been an employee of the Imperial (later Commonwealth) War Graves Commission (IWGC), tending to the graves of those Allied servicemen who fell in the First World War. A veteran of that war himself, he had served as a corporal in the 6th Battalion of the Bedfordshire Regiment. Orpin spent most of his time in captivity in the Second World War in Upper Silesia in Ilag VIII/C Tost, and it is possible that he used his horticultural skills while he was interned.

News of his internment reached his mother, who was living in Bromham, Bedfordshire, and was reported in the *Bedfordshire Times* on 6 December 1940. His final release from captivity took place at Giromagny in north-eastern France and was arranged following a repatriation of prisoners. Orpin returned to his sister's home and remained there until the end of the war, before finally returning to his family in Vimy to resume his employment with the IWGC.

Following the end of the Second World War, the Commission staff were instructed to wear civil defence uniforms and were identified by a distinctive cloth shoulder title bearing the letters IWGC.

Records obtained from the Commonwealth War Graves Commission show that Leonard Orpin continued in their employment until he reached the retirement age of 65 on 31 July 1954. He was awarded a retirement gratuity of £439 16s 8d and granted a pension of £146 13s per annum. It is believed he continued to live in France with his family and is recorded as dying on 1 December 1967 aged 78.

▼ POW card of Leonard Orpin, a gardener for the Imperial War Graves Commission. WO 416/278/96

VI Coding and Forging

Keeping POWs hopeful was an important consideration, and communication was an essential part of MI9's strategy. At the end of 1940, newsletters were sent to camps to try to improve morale. These letters were sent from fictitious people with fictitious addresses and were written in many different styles. They were also useful in spreading rumours, as inevitably the German censors would have to examine a substantial proportion of them.

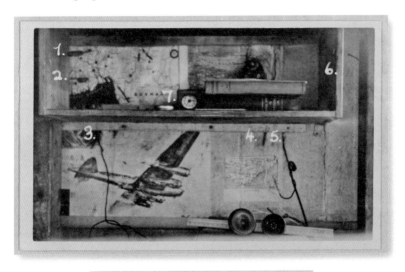

The panels behind which the radio receiver and batteries were concealed. This sets is described in Part IV, Chapter II, Section 1, sub-section (a).

KEY TO NUMBERS SHOWN IN WHITE

1 and 2. Screwdrivers in position for tuning and reaction control. These were inserted through holes in the wooden panel. When the receiver was not being used the holes were filled with wooden plugs which were disguised as towns on the map, all towns being indicated with black spots.
3. Aerial clipped to a nail which passed through the panel and was connected to the receiver.
4 and 5. Earphone leads connected to nails which passed through the panel and were connected to the receiver.
6. Bookshelf, a common feature in most rooms in the Camp. The nails mentioned in 3, 4 and 5 helped to support it.
7. Alarm clock used to waken the operators for the 'Voice of America' programme at 0200 hours daily.

◀ Concealed radio receiver with key to operating instructions in Stalag Luft I Barth. WO 208/3282

Code work

Official codes were devised by Foreign Office experts, the first of which was to be used only in conjunction with a dictionary. After the fall of France in June 1940 other codes were introduced. Code II was the most widely used.

Code work enabled POWs to be reliable sources of intelligence even if the information took a while to reach MI9. Communication by wireless transmitters was probably the most important development, as it reduced the time lag by half. The first wireless coded message was broadcast on January 1943 by Radio Padre. By 1944, the development of radio communications to Germany and Italy meant that IS9 were able to send messages more quickly, but most were still sent by mail. Between 1941 and 1944, IS9 received 9,473 coded messages by mail and sent 3,227. Only 271 messages were sent by wireless transmitters but, more than anything, the broadcasts provided much-needed morale in the camps.

➤ A German–English coding dictionary. WO 208/3566

DESCRIPTION	1942	1943	1944	1945 (4 mths)	TOTAL.
COMPASSES:					
Round Brass	231,568	314,522	692,862	62,985	1,301,937
Medium	750	70,369	59,230	10,212	140,561
Midget	-	8,338	6,056	-	14,394
Tunic	2,033	28,301	19,888	14,874	65,096
Pin Point	-	3,212	19,347	200	22,759
Pencil	-	5,470	7,772	-	13,242
Pen	-	600	735	41	1,376
Comb	-	3,741	11,367	3,211	18,319
Pencil Clip	10,165	32,461	45,339	12,389	100,354
Fly Button	40,060	99,447	160,774	58,947	359,228
Pipe	8,525	990	-	4	9,519
Stud	34,483	30,585	26,523	-	91,591
Marching	-	-	1,100	-	1,100
Swinger	47,706	52,746	86,543	10,072	197,067
Cigarette Lighter	-	-	5,766	16,544	22,310
MAPS:	391,945	404,439	692,862	176,676	1,665,922
In Purses	85,819	128,048	211,332	43,325	468,524
In Pouches	4,938	4,879	2,991	1,679	14,487
HACKSAWS	132,706	221,319	241,874	147,651	743,550
AIDS BOXES	135,515	139,408	248,168	37,109	560,200
BLOOD CHITS	15,856	11,624	-	35,230	62,710
POSTERS	1,440	2,036	1,127	-	4,603
FLYING BOOTS	3,314	3,725	-	-	7,039
ESCAPE BOOKS	10,540	20,014	15,700	356	46,610
SPECIAL KNIVES	-	1,362	2,619	2,511	6,492
PHRASE CARDS	-	15,124	270,827	62,151	348,102

◀ A table listing the most common items that IS9 (Z) produced and distributed. WO 208/3282

POWs were allowed to send and receive letters and parcels. This enabled information to be communicated from both in and out of the camps. MI9 never used Red Cross parcels to smuggle in escape aids or devices for fear that the contents, which would bring some relief to the prisoners, would be confiscated. As such, they were constantly thinking of new ways to get escape aids through to the camps. Coded messages were sent to inform the Escape Committee of their imminent arrival. The parcels would then be smuggled out of the censor room and smuggled back in once the escape aid had been removed. These would have included maps, hacksaws and compasses, as well as equipment needed for forgeries and vast quantities of Reichsmarks.

Led by Clayton Hutton, IS9 (Z) was responsible for the manufacture and supply of the many kinds of escape aids and devices into the camp system. It was a colossal task and one which provided the POWs with a purpose – whether it was practical work towards their own escape or paving the way for others to escape.

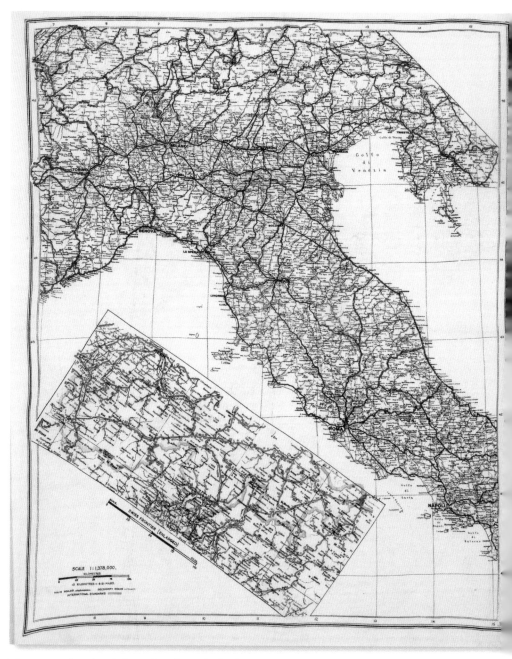

∧ Escape map of northern Italy, southern Switzerland and adjacent areas of France, Austria and Yugoslavia, 1942. MF 1/15



4. PHONEY FUNDS.

(a) The names of 'phoney' Funds, Firms, Societies and Organisations used for the purpose of sending escape material to Ps/W were as follows:-

AUTHORS' SOCIETY.
BRITISH LOCAL LADIES COMFORTS SOCIETY.
BROOM'S SPORTS SHOP, ST. ALBANS.
C & H SPORTS, EXETER.
COUNTIES CLUB.
CROWN & ANCHOR MISSION.
EAST STREET SPORTS SHOP, BRIGHTON.
EDWARDS SPORTS HOUSE, WATFORD.
EMPIRE SERVICE LEAGUE.
FUSSELL'S SPORTS DEPOT, LUTON.
GAMLEY'S, DORKING.
HARPER'S, ATHLETIC OUTFITTERS, COLCHESTER.
HARRIS'S SPORTS DEPOT, BRISTOL.
JIGSAW PUZZLE CLUB, LONDON.
LANCASHIRE PENNY FUND.
LEAGUE OF HELPERS.
LICENSED VICTUALLERS SPORTS ASSOCIATION.
LIVERPOOL SERVICE MEN'S CLUB.
MAYFLOWER FELLOWSHIP SOCIETY (LONDON CHAPTER).
NU-SPORTS CO., GRANTHAM.
PRISONERS LEISURE HOURS FUND.
PUBLIC INSTITUTIONS & HOSPITALS ASSOCIATION.
SERVICE MEN'S CLUB, CHATHAM.
SPORTS CRAFT (MFRS), NEWPORT.
THE PEABODY FUND.
THE TRAVELLERS' ASSOCIATION.
THE WILBERFORCE FOUNDATION.
TINGITAS DISINFECTANTS LTD.
WELSH PROVIDENT SOCIETY.
WELSH SPORTS LTD, CARDIFF.
WEST END SPORTS, GLASGOW.
WOMEN'S UNITED SERVICES ASSOCIATION.

(b) Labels were also used for 'Phoney' parcels as from:-

F.W. SMITH & CO. LTD.
OLD TOBACCO CO. LTD., LONDON.
CHRIS JAMES, HIGH STREET, BROMLEY.
RICHMOND SMOKING MIXTURES.

5/..........

5. PARCELS TO P/W CAMPS.

(a) It was evident very early on that our Ps/W would have to depend largely on the British Red Cross Society for food. It was decided, therefore, that, so far as our clandestine work was concerned, no attempt should ever be made to get contraband articles into the Camps under the protection of Red Cross labels. Next-of-kin parcels (one every quarter to each P/W) were also banned, since they were sent under the auspices of the Red Cross. We never broke this rule in any way. The means adopted for getting escape material into Camps was mainly through certain fictitious firms, clubs and organisations which we invented. In order to gain the confidence of the Germans we first sent a letter to each Camp Commandant stating that money had been collected to supply our Ps/W with games, books and comforts, in an endeavour to lighten the burden of their captivity and that a consignment of parcels would shortly arrive which we hoped he would allow the S.B.O. or Camp Leader to distribute. The first, and one of the most successful, of our "phoney" organisation was given the name "The Prisoners Leisure Hours Fund". A list of the organisations, firms, etc. used at various times is given in Para. 4 below. In order to conceal the contraband material as well as possible a few well known and reliable firms were taken into our confidence who entrusted the work of making cavities in the articles to be despatched, and of loading them with escape material to a few of their most trusted workmen. It speaks well for the integrity of these craftsmen that, so far as we know, never once was the game given away in this country. In 1943 through the skill and ingenuity of the Ps/W themselves, it was possible to send out all-contraband parcels to many Camps without any concealment of the articles inside the parcels whatsoever, the Ps/W themselves being able to steal them before they were handled or examined by the German censors.

(b) The method of despatch of parcels entailed detailed arrangements with the Post Office Censorship Dept. The parcels were sent in sealed Mail bags to their P/W Section at AINTREE. On receipt each parcel was stamped as having been examined, although no examination was actually made by the Censorship officials. The parcels were then mixed with genuine parcels despatched from various stores and other licence holders and sent to their destinations.

(c)/..........

▲ Methods of reproducing maps in Stalag Luft I Barth. WO 208/3282

▲▶ List of thirty-two fabricated organisations as undercover suppliers of parcels. WO 208/3282

▶ Historical record of MI9 regarding the supply of parcels to POWs. WO 208/3242

Supplying maps was a fundamental part of MI9's work. Much of the information was gathered from escapees who successfully returned to Britain. Coded letters from camps to MI9 often asked for maps of specific areas for escape planning. The maps were smuggled in using ingenious methods and were often reproduced within the camp system.

In order to smuggle information and aids into camps, MI9 created fictitious organisations that were covers for sending parcels.

➤A design for concealing escape aids in battledress.
WO 201/1417

▼ Ways of concealing escape aids in Stalag Luft I Barth.
WO 208/3282

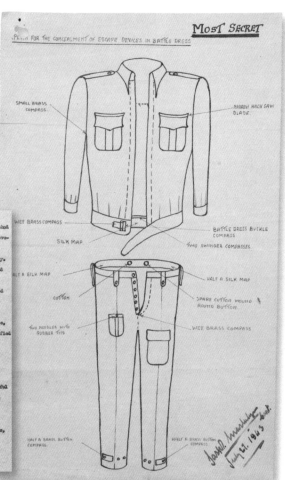

VII Deportation

The UK policy of internment changed dramatically in the spring of 1940, following the German invasion of the Low Countries and France, and the Allied forces' retreat to Dunkirk. In the late May and early June of that year, following the fall of France, some 40,000 British servicemen were captured and taken to POW camps. Similarly, thousands of British civilians working and resident in German-occupied territories were taken to internment camps, most of which were set up in France.

With the risk of German invasion high, regardless of their initial tribunal category classification, a further 8,000 Germans and Austrians resident in the southern strip of England found themselves immediately interned in camps and reclassified from Category C to Category A. In addition, 18,000 resident Italians were also considered for internment, following Italy's declaration of war on Britain on 10 June 1940, meaning that the number of internees in the UK swelled to nearly 30,000. Nearly 5,000 Italians were interned (just under a third of all Italians living in the UK).

In June 1940, a decision was also taken to deport 4,000 internees overseas because of concerns over the available space to accommodate the growing numbers, coupled with the suspicion that many of them were enemy agents helping to plan an invasion of Britain.

Five vessels (SS *Duchess of York*, SS *Arandora Star*, HMS *Ettrick*, MS *Sobieski* and HMT *Dunera*) were selected to transport these internees to Canada. On 10 July 1940, over 2,500 internees, initially led to believe they were going to Canada, embarked on a journey to Australia on HMT *Dunera*.

Jewish refugee Heino Alexander was arrested and interned on the Isle of Man in June 1940. Almost immediately, with hundreds of other enemy aliens, he was deported to Australia on HMT *Dunera* and he recorded his harrowing experience in his personal diary, which is housed at The National Archives and has recently been translated:

> Now on 10th July towards the evening, we have reached Liverpool and saw from a distance the ship that is to take us to Canada. Then the reception on the Dunera was a shock. All the luggage we had with us,

we were allowed only 80 lbs, was torn out of our hands and dumped in a huge pile. Our pockets were searched, and things stolen. We even got kicked and hit with rifle butts if anyone was not quick enough. Then we were driven down by the troops on the ship, rounded up like cattle and packed onto individual decks. The worst thing was that we were sitting behind barbed wire. Here below deck it was shocking. Everything, absolutely everything was taken from anyone who appeared even a little well-to-do. Papers and important documents were torn up and thrown away. We numbered some 2,600 people, crammed together like cattle.

The journey to Australia lasted fifty-eight days. Over 2,500 internees were crammed aboard, comprising Jewish refugees, Nazi sympathisers and some 200 Italians. The Jewish refugees and Nazi sympathisers were classified simply as Germans, and this caused resentment and conflict on the journey. The ship had an official maximum capacity of 1,500 – including crew – and the resultant conditions have been described as 'inhumane'. The voyage was also made under the risk of enemy attack.

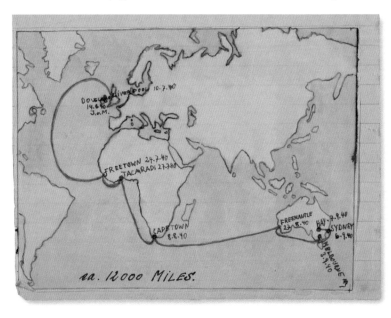

➤ Alexander drew a map recording his fifty-eight-day journey in 1940 from the Isle of Man to Hay in New South Wales, Australia, and the return journey one year later. HO 215/263

On 12 July, Alexander recorded in his diary:

Early in the morning, I was wakened by a dreadful noise and shortly after came a terrible crash. Afterwards we learned that two torpedoes had been fired at our ship but thank God, due to the height of the waves, did not reach their target. We could not have hoped to be rescued, for first of all, we were locked in behind barbed wire and we would all have been squashed to death and secondly there were guards at all the exits to the deck with their guns loaded and would have shot down anyone who tried to break through the barbed wire. There were clearly not enough lifeboats on board for everyone. We never had any lifeboat drills so you can guess what would have happened in the event of an emergency.

> Over 2,500 internees were crammed onto HMT *Dunera* for its fifty-eight-day voyage to Australia from Liverpool. Pro-Nazi Italian Fascists were not separated from Jewish refugees, leading to inevitable conflict. HO 215/1

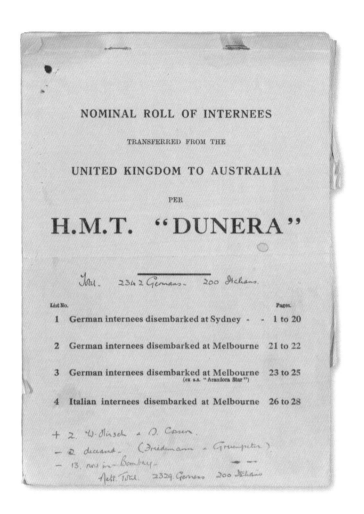

NOMINAL ROLL OF INTERNEES

TRANSFERRED FROM THE

UNITED KINGDOM TO AUSTRALIA

PER

H.M.T. "DUNERA"

Total. 2342 Germans - 200 Italians.

List No.		Pages.
1	German internees disembarked at Sydney - -	1 to 20
2	German internees disembarked at Melbourne	21 to 22
3	German internees disembarked at Melbourne (ex s.s. "Arandora Star")	23 to 25
4	Italian internees disembarked at Melbourne	26 to 28

+ 2. W. Hirsch & D. Cohen.
– 2 deceased. (Friedmann & Grumpeter)
– 13. now in Bombay.
Nett. Total. 2329. Germans 200 Italians

On arrival in Sydney, the first Australian to come aboard was medical army officer Alan Frost. He was appalled by the conditions he found, and his subsequent report led to the court martial of the army officer in charge, Lieutenant Colonel William Scott.

Tragically, on 2 July 1940, another ship deporting internees overseas, SS *Arandora Star*, was torpedoed and sunk in the Atlantic en route to Canada, resulting in the loss of over 800 lives.

VIII Medical Treatments

Many POWs fell into captivity after a period of hard fighting before their surrender. Some, therefore, had suffered recent physical and psychological injuries that had to be treated and, once again, the provision for this care for those held in Europe was ensured, as far as possible, by the Geneva Convention. For those in Japanese captivity, medical care was much more haphazard and improvised. Working conditions were far more dangerous and the threat of tropical diseases and malnutrition was never far away. Survival often came down to luck: where someone was held and whether suitable medical expertise was to be found in the camp.

Although less likely to have suffered physical injuries prior to their capture, internees were likely to be older than POWs. Many were in their 60s, though it was unusual for internees to be over the age of 70. Those who were infirm or suffered from physical or mental ailments were more likely to be exchanged or repatriated.

Lazarettes were military hospitals for POWs and internees in Nazi-occupied Europe. They were usually staffed by captured medical personnel, but other prisoners with a non-medical background were often required to work as orderlies, cleaners and hospital administrators. They were usually specifically inspected by the Red Cross – as the care of the sick and wounded was protected by the Geneva Convention – and POW repatriations were organised when possible.

Lazarettes were used to treat a huge range of ailments and diseases. Some would receive more treatment than others, such as 23-year-old RAF flying officer Maurice Buttler. There are twenty cards for this one man in his personnel record (held at The National Archives), when the average number is typically one or two cards per individual. Fifteen of these are on pink-coloured card, indicating hospital treatment. There are also four head-and-shoulder photographs, three full-face and one in profile. On inspection of these, it appears as though he had had recent surgery on his face.

Buttler later became a member of the 'Guinea Pig Club'; membership was confined to those RAF and Allied forces airmen who

Report on the manufacture of artificial limbs and war equipment, POW Base Hospital, Nakom Paton, March–October 1944

'NO expert knowledge in technical construction was available for production of anything approaching to the present day artificial limb. No assistance has been given by I.J.A. [Imperial Japanese Army] in provision of materials. The only practical solution lay in improvisation with material at hand, despite imperfect and insufficient tools.

'The importance of function in correcting contractures of the stump and of the psychological effect of restored mobility, apart from crutches, was appreciated. Personnel from various POW grps, formerly associated with pylon construction were incor[po]rated in the workshop. A standard design was adopted, production rate being improved, and progress in design and efficiency has been achieved although still far from present day perfection.'

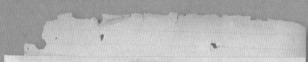

➤ WO 222/1389

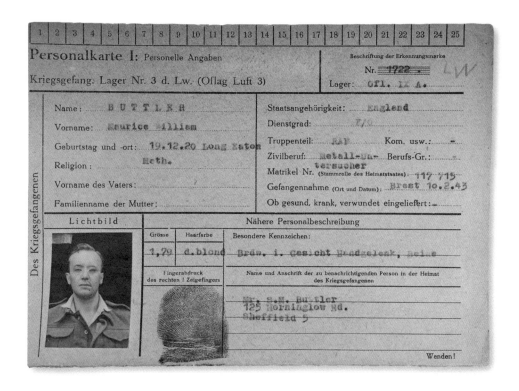

Personalkarte I: Personelle Angaben

Kriegsgefang. Lager Nr. 3 d. Lw. (Oflag Luft 3)

Beschriftung der Erkennungsmarke
Nr. 1722 .
Lager: Ofl. IX A.

Name: B U T T L E R
Vorname: Maurice William
Geburtstag und -ort: 19.12.20 Long Eaton
Religion : Meth.
Vorname des Vaters:
Familienname der Mutter:

Staatsangehörigkeit: England
Dienstgrad: F/O
Truppenteil: RAF Kom. usw.: -
Zivilberuf: Metall-un- Berufs-Gr.: -
 tersucher
Matrikel Nr. (Stammrolle des Heimatstaates): 117 715
Gefangennahme (Ort und Datum): Brest 10.2.43
Ob gesund, krank, verwundet eingeliefert:-

Des Kriegsgefangenen

Lichtbild Nähere Personalbeschreibung

Grösse | Haarfarbe | Besondere Kennzeichen:
1,79 | d.blond | Brdn. i. Gesicht Handgelenk, beide

Fingerabdruck Name und Anschrift der zu benachrichtigenden Person in der Heimat
des rechten I Zeigefingers des Kriegsgefangenen

Mr. S.M. Buttler.
125 Horninglow Rd.
Sheffield 5

Wenden!

underwent treatment for severe burns at the talented hands of plastic surgeon Archibald McIndoe at the Queen Victoria Hospital in East Grinstead, Sussex.

A POW card of Maurice Buttler. WO 416/53/114

The POW hospitals were staffed by Allied medics and the hospital at Bad Soden in Germany was run by Major David Charters of the Royal Army Medical Corps, who was an eye specialist. Something of an unsung hero, Charters – who had had no experience of plastic surgery before the war – became adept in treating eye injuries, including burns. He corresponded with McIndoe, seeking advice on procedures, managing with improvised surgical instruments and whatever could be obtained through the International Committee of the Red Cross. His dedication was such that he refused repatriation in order to continue his work in the hospital.

At Nakom Paton, a hospital camp close to Bangkok with the capacity to hold 10,000 prisoners, medical personnel dealt with a variety of diseases

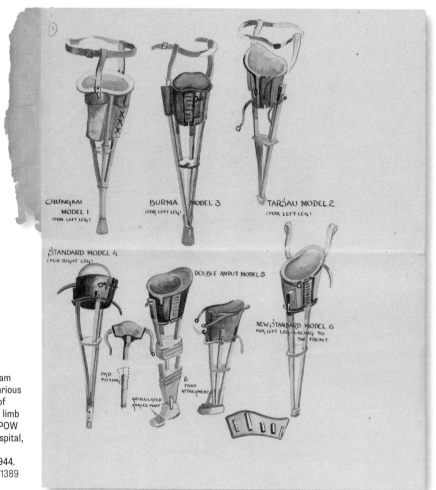

➤ Diagram
of the various
models of
artificial limb
used at POW
Base Hospital,
Nakom
Paton, 1944.
WO 222/1389

and injuries suffered by Allied POWs. Despite there being no expert knowledge on their technical construction, large numbers of artificial limbs were produced for POWs who had obtained injuries that required amputation. As many as eighty-one limbs were constructed from the middle of August to the end of October 1944.

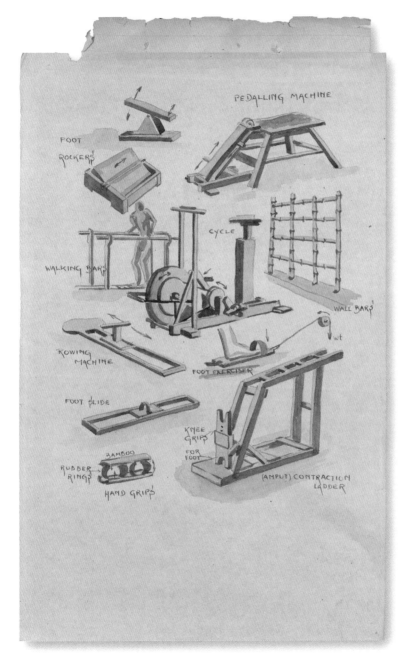

FOOT ROCKERS

PEDALLING MACHINE

CYCLE

WALKING BARS

WALL BARS

wt

ROWING MACHINE

FOOT EXERCISER

FOOT SLIDE

KNEE GRIPS

FOR FOOT

BAMBOO

RUBBER RINGS

HAND GRIPS

(AMPUT.) CONTRACTION LADDER

◄ Diagram of exercise equipment produced at POW Base Hospital, Nakom Paton, 1944. WO 222/1389

COPY.

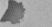

38 Porchester Terrace,
London, W.2.

December 8th 1941.

Dear Mr. Maxwell,

PW/C.732 - Lt.Col. B.H. Bonham-Carter.
ILAG VIII TOST.

Having had four letters and eight postcards all at once from
my son (above numbered) I give you the extract below, for your
information as it may be useful to you, giving the reason for
parcels being pilfered elsewhere. Obviously no action on your
part can stop it, but I think we may reasonably assume that my
son and his friends will have dealt with it and put it right locally.

"Letter 28th October. The Red Cross parcels have been coming through
excellently. There seems to be a bit of a racket in their distribution
as there was in ILAG XIII. There it was carried out by those amongst
us who called themselves "British Passport Holders." They are
correct - it is the only claim they have on Britain. There they had
a large say in the distribution of parcels after they had been opened
by the Censor. It appears they have here too, with the same
result. Parcels do not arrive intact in the hands of the recipients.
Valuable things like tea, bacon, sausages, etc. are apt to disappear
en route or be replaced. Well, we fixed that at Ilag XIII, by
just changing the whole "British" staff of the camp from Camp Captain
downwards. We can do the same here. Several of us are looking
into matters - keeps one quite busy."

Yours sincerely,

(Sgd) H. Bonham-Carter.
Lt.Col.

J. Maxwell, Esq.,
Assistant to Managing Director.
Prisoners of War Department,
St. James's Palace,
London, S.W.1.

⌃ Brian Hulbert Bonham-Carter - interned while visiting Oulchy-le-Château, France, in the
spring of 1940 - complains to his father in the UK about the pilfering of Red Cross parcels
at Ilag VIII/C Tost. The letter helps to explain how the camps were administered, how the
internees ensured that their voices were heard and how they demonstrated resistance to
unfair treatment. FO 916/39

4

Escape

POWs and internees had some agency in how they conducted themselves in captivity and this took many forms. These were exhibited in small acts of resistance that sought to undermine their captors' authority, but also, occasionally, led to collaboration with their captors, sometimes with deadly consequences. Some POWs and internees collaborated with the Germans to influence fellow prisoners, in espionage, or even to join their military forces. Collaboration also occurred under Japanese authority, most famously when tens of thousands of Indian POWs helped form the Indian National Army to fight against Allied forces.

Escape was uncommon in internment camps but that did not mean the captives were content. Many would complain about the lack of heating, the cramped conditions and the inferior quality of food. These complaints would be noted in Red Cross inspection reports.

The ultimate form of resistance was a physical escape from captivity. These escapes came in many guises, from simply climbing and jumping fences, to prisoners disguising themselves as guards, digging tunnels or building gliders. The famous 'Great Escape' from Stalag Luft III can be included here, but there was a variety of other incidences in both Europe and the Far East. These were often supported by intelligence services, particularly MI9, in the case of prisoners in Nazi-occupied Europe.

Personalkarte I: Personelle Angaben

Oflag VII C
A.O.

Kriegsgefangenen-Stammlager:

Beschriftung der Erkennungsmarke
Nr. 214

Lager: 6 JUNI 1940

Name: Bonham-Carter
Vorname: Brian Hulbert
Geburtstag und Ort: Lahore (Indien) 15.5.89
Religion: my. K.
Vorname des Vaters: Herman
Familienname der Mutter: Watson

Staatsangehörigkeit: Brit. Inder
Dienstgrad: Oberstleutnant a. D.
Truppenteil: ...
Zivilberuf: Offizier d. R.
Matrikel Nr. (Stammrolle des Heimatstaates):
Gefangennahme (Ort und Datum): Auchy le Chateau 20.5.40
Ob gesund, krank, verwundet, eingeliefert:

Lichtbild

Größe 180
Haarfarbe grau

Nähere Personalbeschreibung
Besondere Kennzeichen:

Fingerabdruck des rechten Zeigefingers

Name und Anschrift der zu benachrichtigenden Person in der Heimat des Kriegsgefangenen
Dorothy Bonham-Carter
Elton-Ilminster (wife)
Somerset - my.

Wenden!

▲ Brian Hulbert
Bonham-Carter's
internment
record card.
WO 416/299/186

➤ Hulbert
Bonham-Carter's
internee
metal ID tag.
WO 416/299/186

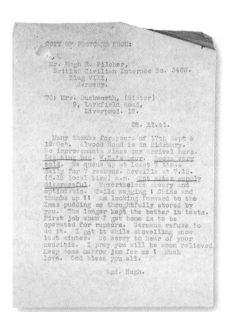

COPY OF POSTCARD FROM:

Mr. Hugh R. Pilcher,
British Civilian Internee No. 345W.
Ilag VIII,
Germany.

TO: Mrs. Duckworth, (Sister)
9, Larkfield Road,
Liverpool. 17.

28. XI.41.

Many thanks for yours of 17th Sept &
12 Oct. Alwood Road is in Didsbury.
No improvements since our arrival here.
Lighting bad, W.C.'s poor. Began very
cold. We queue up at least 7 times
daily for 7 reasons. Reveille at 7.15.
(8.15 local time) a.m. Hot water supply
disgraceful. Nevertheless cheery and
optimistic. Tails wagging ! Chins and
thumbs up !! Am looking forward to the
Xmas pudding so thoughtfully stored by
you. The longer kept the better in taste.
First job when I get home is to be
operated for rupture. Germans refuse to
do it. I got it while shovelling snow
last winter. So sorry to hear of your
neuritis. I pray you will be soon relieved
Keep some marrow jam for me ! Much
love. God bless you all.

Sgd. Hugh.

◄ Sixty-year-old British businessman Hugh Robert Pilcher was operating in Vieil-Hesdin in northern France when he was arrested and interned on 21 May 1940. Initially he was sent to Ilag XIII in Wurzburg, Bavaria, before being transferred to Ilag VIII/C Tost in Upper Silesia, where he met fellow internee Brian Hulbert Bonham-Carter. Within a month of his arrival, he wrote to his sister in Liverpool complaining about the lighting, heating and toilet facilities, but his letter was equally optimistic and cheery, looking forward to the Christmas pudding his sister had sent him. FO 916 39

▼ Pilcher's internment record card. WO 416/290/287

The security services and MI5 also took a keen interest in civilian internees involved in suspicious activities and many would be convicted of collaborating with the enemy.

| Planning and Organisation

As a result of not having to work while in captivity, officers held in Europe could have copious amounts of spare time to fill. For many, this meant more time to hatch plans for their escape. Sometimes escapes were planned and attempted by individuals, while others were organised by small groups of people acting independently. Due to the hierarchical nature of prisoner life, escape committees, which came in a variety of forms, were established, and often approved (or not) plans for escape.

In some circumstances, these committees restricted their role to a purely advisory one. At other Allied POW camps their role could be much more active, and involve a series of formalised processes for obtaining approval to escape. At Stalag Luft III in 1942–43, for example, if a prisoner had a plan for escape, he had to first talk to the appropriate escape representative in his barracks, who would speak to a member of the planning staff, at which point a plan was then worked out in detail. This would be explained to the head of the escape committee, who would make the final decision as to whether it would be carried out, and by whom.

▼ Decoded
letter requesting
dye for making
German
uniforms.
AIR 40/2622

Behrens & Baumeister Werden/n makers of dry fruit mixtures. Frank & repon Bromberg makers of k.honig. ＊ Escape organisation forgery dept. had marked success with various documents supplied to number of escapees on 5 March, but have considerable difficulty obtaining originals to copy. Therefore request tracing of: identity card for foreign workers in Germany. Leave pass ditto. Suggest suitable paper as fly leaves in books. Request also powdered Indian ink, three very fine mapping nibs. ＊

I.S.9.(x).
Copy to O.C. I.S.9. + 1 extra copy

The following details 10 of. 43 has been received
from Stalag Luft 3, Sagan:–

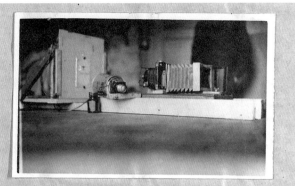

The photographic equipment used by the Forgery Section.

The bellows of the camera extension was made of brown paper, the film holder of wood, and the light reflector from a milk tin. The copy board, shown on the left of the photograph, could be moved up or down, and to the left or right as desired. The camera could be moved towards or away from the copy board and locked in position with wing nuts.

A pass is shown in position on the copy board.

CHAPTER II
ESCAPE ORGANISATION

1. CONTROL BY CAMP AUTHORITIES

The Escape Committee had been set up before the transfer from the East Compound, and had already done all preliminary planning and was ready to come into action as soon as the move took place.

The first Head of the Committee was:-

90120 S/Ldr. R. BUSHELL, R.A.F.

The Committee assumed a complete and strict control of all escape activities, and attempts. It had the support of the Senior British Officer, who was responsible for the appointment of BUSHELL.

Plans had already been made for the construction of three large tunnels, and no other tunnels were allowed to be constructed.

Escape activity Departments, their work and their staff had already been planned in considerable detail. They are described in subsequent Sections of this Chapter. Heads of Departments attended all full Committee meetings and any other meetings when matters involving their Departments were discussed.

Those actually making the escape could not do everything alone, especially if the plan included a mass escape. To prepare for the latter, rations, forged papers and clothing had to be produced to aid those who were required to travel many hundreds of miles in enemy territory and to safety.

‖ The 'Wooden Horse' Escape

Oliver Philpot, along with Michael Codner and Eric Williams, took part in the 'Wooden Horse' escape on 29 October 1943. To escape, a vaulting horse was constructed out of stolen material and placed on the ground to disguise the digging of a concealed tunnel in the exercise area of the camp. The tunnel took 114 days to construct, and Philpot made his way north alone disguised as a Norwegian salesman, an identity he created before successfully escaping.

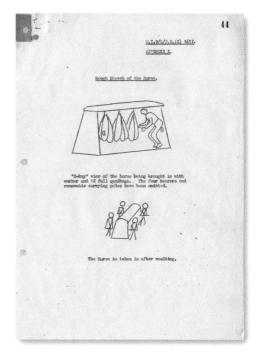

➤ Rough sketch of the wooden horse constructed to help build the tunnel, including details about how the horse was moved and the sand concealed, 1943. WO 208/3317

'1. I was a prisoner of war at Stalag Luft III and took part in the tunnel escape in March 1944. During the previous summer I had been concerned in the escape organisation on the security side and also helped with the digging and dispersal.
2. On the night of the escape I was the 39th officer to pass through the tunnel.'

SECRET

D (vii)

6.

UNITED KINGDOM CHARGES AGAINST GERMAN WAR CRIMINALS

CHARGE NO. U.K. - G/B.70.

SHOOTING OF 50 R.A.F. PRISONERS OF WAR FROM STALAG LUFT III.

STATEMENT of 42232 Flight Lieutenant B. JAMES, home address 56 Kimbolton Road, Bedford.

Flight Lieutenant James states :-

1. I was a prisoner of war at Stalag Luft III and took part in the tunnel escape in March 1944. During the previous summer I had been concerned in the escape organisation on the security side and had also helped with the digging and dispersal.

2. On the night of the escape I was the 39th officer to pass through the tunnel. F/L. Green was immediately before me and my partner, F/O. Skanziklas followed. I was one of the party of 12 which was to travel by train from Tchiebsdorf to Boberorsdorf. The party included Major Dodge and I agree with the list of names given by F/L. Green in his evidence. I remember that there was another party of 10 making a short railway journey by the local line further west. My recollection is that F/L. Birkland was in charge and that it included F/L. Stower, F/O. Tonder and F/L. Casey.

3. F/O. Skanziklas and myself were caught at Hirschberg West Station at about 1730 hours on 25th March. We were taken by a policeman and a civilian, who seemed to be a special constable, to the Kripo H.Q. at Hirschberg. I did not see any name on the door of the room in which we were interrogated but I did see on the door of the anteroom leading to the main office the words "Kriminal Polizei". I was interrogated alone in the police station. There were two men and a typist taking part in the interrogation with various other people standing round. The interrogator wore civilian clothes, was bald headed with rather slight build and medium height, he wore glasses. I have looked at the sketch entitled "Prison Governor at Hirschberg" in Addendum No. 6 to the Summary of Information on German Personalities issued by M.I. 9 on 25th October 1944. The sketch resembles one of the officials who was standing by while the interrogation was going on. I remember I said that the escape was a military occupation and this man made some disparaging interjection. The sketch does not resemble either the interrogator or the Meister at the prison.

4. During the interrogation I was asked for information about the tunnel and refused to give it. I was then put into a dark cell for about two hours and then re-interrogated.

5. After the interrogation I was handcuffed and put in the gaol at Hirschberg. This building I understood to be a transit gaol for the Kripo. It was run by a civilian who was thin faced with dark greyish hair rather thin on top, medium height, aged about 50 and wearing glasses who was referred to as Meister. This man wore riding breeches and boots and on one occasion when all the escaped prisoners were present he flourished a revolver at us when we were looking out of the window and he was in the yard below. Lieut. Poynter whould have full particulars of this incident.

6. In the escape I was wearing an R.A.F. officer's tunic which has been dirtied up to look like a civilian workman's jacket with civilian buttons and a pair of Middle East tropical trousers. I wore neither coat nor hat. F/O. Skanziklas was wearing an airman's great coat cut down and dyed and a peaked cap in the German workman's style.

7. At the gaol I was put into a cell with 7 other escapers. On Monday 27th March Major Dodge was taken out. On Wednesday 29th March F/L. Pawluk and F/L. Klewnarski, F/O. Skanziklas and F/L. Wernham were taken out by the warder. We had no idea of their destination and I have never seen any of them since.

8. On Thursday 30th March at 4 a.m. Lt. Poynter and F/L. Green were taken away by the warder and I was left by myself. I stayed in the gaol for a further week until 6th April although I was put into a different cell during that time. I was treated as an ordinary criminal given nothing to read or

/smoke......

◄ Statement made by Flight Lieutenant Bertram 'Jimmy' James about his involvement during the escape and his subsequent recapture, 1945. AIR 40/2275

III The 'Great Escape' from Stalag Luft III

On the night of 24–25 March 1944, after months of preparation and work, seventy-six RAF officers at Stalag Luft III escaped through a 333ft-long tunnel, nicknamed 'Harry', in an effort to reach Allied or neutral lines. In what became known as the 'Great Escape', all but three were recaptured and fifty were subsequently murdered. This put a stop to all future escape attempts, while an extensive investigation took place after the war in order to bring those responsible for the killings to justice.

Lesley Bull

Reginald Kierath

John Stower

Ivor Tonder

George Mondschein

John Williams

Extract from the investigation into the death of Squadron Leader Roger Bushell during the escape from Stalag Luft III

'After the escape of the 76 R.A.F. officers from Stalag Luft III at Sagan on 25th of March 1944 a nation-wide search was instituted and during the ensuing days all except three of the officers were recaptured. The decision that 50 of the recaptured officers should be killed by the Gestapo was made on the highest level, probably on the 25th of March 1944. The responsibility for this order forms a charge in the indictment against GÖRING and KEITEL who are being tried by the International Military Tribunal at Nuremberg as major war criminals. Had it been possible to bring HITLER and HIMMLER to trial they too would have been similarly charged. The hearing before the International Military Tribunal is now approaching its end and the judgment is expected shortly.'

◄ AIR 81/507

MOST SECRET

Mr. Bonsall,
Room 71,
Block 'F'.
- - - - -

5 Apr 44.

AT. No. 785 of 29.3.44.

To Kripo, WORMS, OFFENBACH, GIESSEN.

70 British officers recaptured. Extraordinary state of
search to be reduced to strengthened state of search (war-time).
Search and guard over railways and borders to be continued in full
force. Wehrmacht must continue search with adequate forces.
From Kripo DARMSTADT.

(Cf. AT 774, 767. Refers to mass flight of 80 British flying
officers from SAGAN).

IV Airey Neave Escapes Colditz

On 5 January 1942, wearing a fake German uniform and carrying forged
papers and a compass, Airey Neave escaped Colditz with a Dutch officer
during a theatrical production, via the stage trapdoor. After two weeks,
enduring freezing conditions and suffering with snow-blindness, they
reached the Swiss border and eventual freedom. Neave was the first
British officer to escape Colditz.

Almost as soon as he arrived safely back in England, Neave was
recruited by MI9 to the most secret of sections, known as Room 900.
With his gathered knowledge of how the escape routes were used across
Europe, he was tasked with looking after secret communications and the
handling and running of agents. His clandestine work enabled escape
lines to operate through France, Belgium and Holland throughout
the war.

'I was convinced that the best method of escaping was by posing as a German. I was forced to the conclusion, however, that even a German officer could not leave the gate of the prisoners' courtyard unchallenged, and to be challenged spelt disaster. The only solution was to avoid being challenged at all. This I decided could only be done by emerging from the guard-room in the German officer's uniform. I, therefore, planned to escape on those lines.'

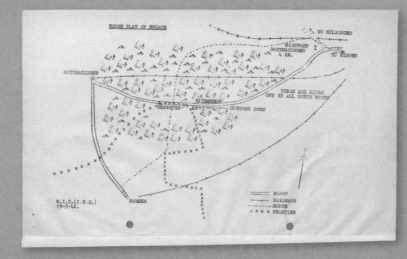

◀ Neave's account of his third, successful, escape attempt, May 1942. WO 208/3308

◀ Rough plan of escape from Colditz Castle, January 1942. WO 208/3308

> Example of
information
following an
interview with an
escaper and the
intelligence he
supplied about
his escape route
through France.
WO 208/3242

4. Journey from SAGAN:

(a) Papers, Clothes, etc:

According to plan we went our ways independently. CODNER
and WILLIAMS had originally intended to walk, but, owing to the
cold at night, they had altered this plan and were intending to
take the train to STETTIN and catch a boat.

I had decided immediately after the R.A.F. SCHUBIN break of
.33 on 5-6 Mar 43 that train travel was the best escape method,
especially if one remembered the trip of Flight Lieutenant CRAWLEY
to somewhere near MUNICH, Squadron Leader CALNAN and Flight
Lieutenant KEE almost to COLOGNE, and Flight Lieutenant STEVENS
to HANOVER via BERLIN, all using indifferent papers. Accordingly,
I had since April been preparing such a trip, and I hoped that
some opportunity for a break would come.

My story was that I was Herr JON JÖRGENSEN, a Quisling
Norwegian (hoping I would never meet a Norwegian as I was ignorant
of the language) on an exchange from DENOFA A/K., FREDRIKSTAD, to
the Margarine Verkaufs Union, BERLIN, and doing a tour of all
branches, factories, etc. anywhere in GROSSDEUTSCHLAND. A very
fine set of papers were provided in the camp. The papers were:-

1. Vorläufige Ausweis - an original, and the first time we
 have used one of these.

2. Two polizeiliche Erlaubnisse. One original.

3. One Bescheinigung.

4. Arbeitskarte.

5. Bestätigung (Certificate of Issue of Arbeitsbuch).

6. Typed letter from the Margarine Verkaufs Union, introducing
 me.

7. Typed letter from the National Samling, asking me in
 Norwegian to go and hear Quisling speak about the
 reconstruction of Europe.

8. Membership card of the National Samling.

9. A very bogus Swedish sailor's pass added for the dock part
 of the journey.

My outfit was essentially respectable. Once I started
looking like a tramp I considered I should be ruined. I had a sort
of Anthony Eden hat, Hitler moustache, R.A.F. officer's greatcoat,
R.A.F. gloves, a new pair of shoes, a pair of Fleet Air Arm trousers
and a non-descript black civil jacket. I carried a small vulcanite
suitcase with, primarily, the means to keep looking well-shaved
and smart in it and, secondarily, some of the camp escape food
disguised as a margarine product. I had a pipe to cover any
linguistic lapses and to give an excuse for not speaking clearly.

(b) SAGAN to DANZIG:

Perusal of the illicit time table in the camp had indicated that
we ought all three to catch the BERLIN express at 1900 hrs. As I
queued up for my ticket at SAGAN station I found CODNER just ahead
SAGAN Station of me, and we both purchased the necessary tickets. WILLIAMS, who
does not speak a word of German, then accompanied CODNER on to the
platform and once the train had started I never saw them again.
The train was half an hour late and very crowded. I stood in
the gangway of the third class and no one paid me any attention.

FRANKFURT- I left the train at FRANKFURT-A.D.-ODER. There was
A.D.-ODER unfortunately no further connection that night, so I walked down

/one of the main

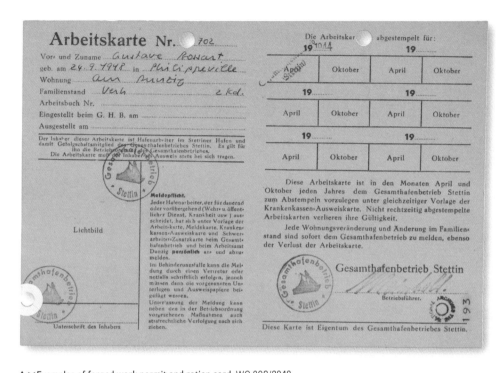

Examples of forged work permit and ration card. WO 208/3242

V Alfred Minchin and the British Free Corps

After his capture in March 1942, merchant seaman Alfred Minchin
was offered the chance to join the newly created British Free Corps, a
unit of the Waffen-SS created by Nazi authorities, consisting of British
and Commonwealth POWs. Prisoners were offered the chance to visit
'holiday camps', where they were given more freedom and amenities
than in their POW camps, while the corps leaders were given freedom to
move around Germany without a guard. Many of its members were tried
at the end of the war. Alfred was no exception and was given seven years'
imprisonment for 'conspiracy to assist the enemy'.

1

➤ Photograph
of Alfred
Minchin (centre)
and Kenneth
Berry in their
Waffen-SS
British Free
Corps uniforms.
The Union Flag
is visible on
the sleeve of
the uniform,
June 1944.
HO 45/25817

War Office.

11th July, 1945.

FURTHER STATEMENT OF Able-Seaman Alfred Vivian MINCHIN,
aged 28, a Merchant Seaman, at present residing at
48, Ellerton Road, Tolworth, Surrey.

1. I have again been cautioned that I am not obliged to say
anything but that whatever I do say will be taken down in writing and
may be given in evidence. (Signed) A.V. MINCHIN.

2. With further reference to paragraph 29 of the statement I
made to you on the 8th June, 1945, which has been read over to me, I
have now been shown a photograph of myself and Kenneth BERRY in British
Free Corps uniform. This is a copy of one which was taken by a German
Naval Officer at MILAG about June, 1944. I had some copies given to
me at the Camp at Milag by another German Naval Officer, but I destroyed
all the copies in the outskirts of Berlin about March this year when
the Russians were approaching. I did not want anybody to find these
photographs in my possession.

3. In the photograph there are also a German Feldwebel, and a
GEFREITER (Lance-Corporal), but I do not know their names. They were
both on the staff of Milag and Marlag Nord. The photograph was taken
just outside the Camp by the Censoring Office.

4. The one stripe on my left arm signifies the rank of Senior
Volunteer in the Waffen S.S.

5. This further statement has been read over to me and is true.

(Signed) A.V. MINCHIN.

Statement taken, read over and signature witnessed by me.

(Signed) P.A. EDWARDS.

◄ Extract from
a statement
made by Minchin
confirming that
it is him in the
photograph, and
that he originally
had copies of the
photograph, which
he destroyed in
Berlin before the
Russian Army
could find them
in his possession,
July 1945.
HO 45/25817

VI Ralph Goodwin Escapes from Sham Shui Po

▼ Map of
Sham Shui Po
officers' POW
camp, which
includes a dotted
line denoting
Goodwin's
route of escape,
July 1944.
ADM 178/339

Initially in hospital with injuries sustained before his capture, Ralph Goodwin was moved to Sham Shui Po, a camp situated in Hong Kong, to continue his recovery. After two and a half years in the camp, in July 1944, not heeding warnings against attempting to escape, Goodwin made his way out of the camp at night and swam across to mainland China. After eleven days evading capture, he linked up with Chinese civilians who helped him travel thousands of miles westward, by any means at his disposal, and to safety.

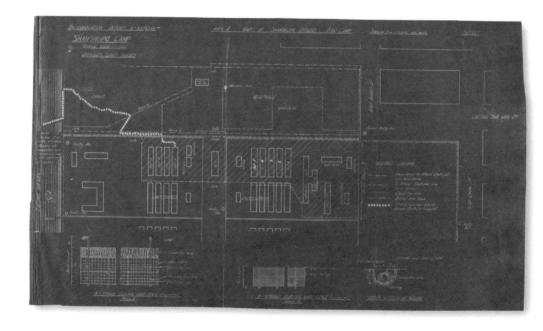

'The night of the 16/17 Jul was intensely dark with heavy showers and blustering squalls, so at 0030 hrs on 17 Jul. E/5 [Goodwin] dressed under his mosquito net, slipped out of bunk, picked up his pack and water bottle, and walked out of the hut without meeting anybody on the way.'

- 30 -

Across the northern ends of the huts a concrete path ran the full width of the Camp, then there was a large open drain about five feet wide and four and a half feet deep, then a roll of concertina wire, then a narrow pathway between the wire and fence K, which formed the northern boundary of the Camp. E/5's escape route is marked •••• on the diagram. A few yards from Hut 6, he crossed a small bridge over the drain, crawled under the concertina wire and along the pathway alongside fence K to a lamp at point B which was about midway between the Western boundary of the Camp and the sentry posted at the sea wall. He chose that spot because the attitude of the camp towards escaping was such that he feared some of the officers just as much as he feared the sentries, and it was essential that no one should know of his attempt.

Fence K was a formidable obstacle. On the Camp side of the posts were four electric wires, the top one about 4 ft. 6" from the ground. On the other side of the posts was barbed wire netting with an eight inch mesh which was 6½ feet high, and on top of that was a roll of concertina wire about 2½ to 3 feet in diameter. Most of the fence posts went just to the top of the concertina wire but the lamp posts were some 3 to 4 feet higher. These were the only ones over which it was at all possible to climb.

Sentries changed every hour going from the guardhouse through the gate opposite in fence K where three turned westwards and made their way along the concrete pathway to take up their posts on the sea wall. Just after E/5 reached point B the three sentries going on duty at 0100 hrs passed outwards only ten feet away, and he lay still while they went by, and while those they relieved passed inwards. As soon as they were clear, he began to climb his post. There were only two insulators on each alternate post so it meant that the steps were very wide apart. His shoes had crepe rubber soles and being wet and muddy the chances of them staying on the smooth tops of the insulators did not seem very bright. His pack felt extremely heavy when he tried to mount the first and it took all his strength to heave himself up. While negotiating the second step his knee pressed hard against the intermediate wire but luckily he was securely insulated Once on the top insulator it took him but a moment to transfer his foothold to the barbed wire netting and at least one danger was left behind him. He now became hopelessly entangled in the concertina wire, and it was at this time that his heart failed him for the only time during his escape. His efforts to get both legs over the wire were so violent that he expected the whole fence to collapse at any moment. The wires were squealing through the staples, and the lamp and lampshade were rattling with a great racket as the post jerked viciously back and forth. It was a full two minutes, it felt like ten before his legs were both clear on the outside of the wire. Why the sentry did not come to investigate the noise is a mystery to him. The only reason E/5 can think of is that he must have been absent from his post. Although his legs were clear, his shirt and shorts were caught in a dozen places by the barbs of the wire, but it was a time for desperate measures, and he just let go and hoped for the best. Luckily they all tore clear and after landing safely he scuttled across the open ground and wriggled under fence M at C. Then making his way around the gasoline trenches he arrived at the sea wall at point D which was at the end of the electric fence. Here he was very pleased to discover that there was only a very broken down barbed wire fence along the sea wall, but he also made the very annoying discovery that he had lost a waterproof hat and pair of long stockings. These had been stuffed inside his shirt, when he slipped out of bed, but in his drop from the main fence, his shirt had been ripped out, and he had been too much preoccupied to notice it. The loss was very unfortunate, for he considered it would give the Japanese a clue to his line of escape. The intense dark and the risks involved made any attempted search quite out of the question.

16/17 Jul.

The night of the 16/17 Jul was intensely dark with heavy showers and blustering squalls, so at 0030 hrs on 17 Jul. E/5 dressed under his mosquito net, slipped out of bunk, picked up his pack and water bottle, and walked out of the hut without meeting anybody on the way.

◀ Narrative of Goodwin's escape from Sham Shui Po, July 1944. ADM 178/339

VII Oswald Job's Treachery

Oswald Oscar Job, a British shopfitter and decorator living in Paris, was arrested on 30 July 1940 as an 'enemy alien' and interned at Front Stalag 122, an internment camp in St-Denis, a suburb of Paris.

He arrived back in England in November 1943, claiming to have escaped from his German captors. British intelligence officers watched him and intercepted messages that confirmed his escape had been engineered by the Germans who intended for him to act as a spy and send back information on British public morale and bomb damage. Job was charged with treachery and hanged on 16 March 1944, aged 58.

▼ Internment card for British civilian Oswald Job, resident in Paris in the spring of 1940. KV 2/50

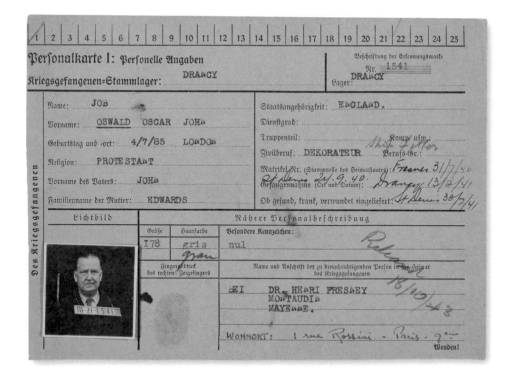

◄ Letter using invisible ink that Oswald was accused of writing to German contacts, 15 December 1943.
CRIM 1/1556

1548.

BRITISH.

No. 681.

Date of visit:
January 22nd, 1945.

Working Detachment depending on Stalag 344, Lamsdorf.

Working Detachment No. E 793, formerly known as Bau- und Arbeitsbataillon No. 21, Blechhammer, O/S.

Accompanying Officer from the German High Command: Hptm. Schade.

British Medical Officers : Capt. Parker, RAMC.
 : Capt. Goodall, ADC.
British Man of Confidence : Sgt. Davies.

 This camp, which used to be independent, is now under direct administration of Stalag 344, Lamsdorf like any other working detachment and is now called: working detachment No. E 793. The same applies to Bau- und Arbeitsbataillon No. 20 Heydebreck O/S, which has become working detachment No. E 794.

 Upon arrival at this working detachment, the Delegate was informed by the German Officer, that the following working detachments in this region:

E 793 Blechhammer	1168	POWs.
E 794 Heydebreck	1117	"
E 3 Blechhammer	854	"
E 711 Reigersfeld	755	"
E 711a "	338	"
E 769 Hohenwald/Reigersfeld	328	"
Total	4560	POWs.

had been ordered to march westward in the early morning of January 21st, 1945. After a march of about 15 km. an order had been received, that they were to return to their respective camps, where they arrived late the same evening.
On the morning of January 22nd, 1945 the POWs went to work as usual, but were returned at once, since the factory had stopped working. They were waiting for new marching orders.

 At the conference with the British Man of Confidence, the Delegate was informed of the bombardment of this camp on December 2nd, 1944 and the unfortunate loss of the lives of 28 POWs., details of which have already been forwarded. A collection had been made amongst the POWs of working detachments

▲ Red Cross report from BAB21, a work detachment of Stalag 344, providing some details at the outset of the 'Long March', January 1945. WO 224/27

5

Liberation and Aftermath

| The Long March

As the Allied armies advanced in Europe, POWs were moved away from the evolving front line, many finding themselves on the 'Long March' in appalling conditions.

As the German Army retreated westward in the face of the advancing Soviet Army during the opening months of 1945, as many as 80,000 Allied POWs were also forced to evacuate westward – a strategy employed to delay their liberation. Conditions were appalling: in the early weeks, temperatures were well below freezing, food was scarce, treatment by the German guards was often harsh, and the prisoners would be forced to march up to 25 miles a day. Some would march a total of 500 miles by the time of their liberation. Many suffered from frostbite, while thousands of others would die of dysentery, typhus and other diseases.

ll Repatriation and Operation Exodus

Detailed plans for the repatriation of POWs and internees in formerly occupied Europe and the Far East had existed well before it was possible to bring anyone home. When peace was declared in Europe, and the majority of Europe had been liberated, it soon became clear that POWs should be evacuated back to the UK as quickly as possible, partly because many were suffering from injuries and malnutrition. This work came to be known as Operation Exodus and began in April 1945. Hundreds of POWs were repatriated each day and transportation of tens of thousands of POWs happened in a matter of weeks. By May, the operation scaled up dramatically, involving over 600 Allied aircraft repatriating over 1,000 POWs each day. By the end of the operation, over 350,000 POWs from all Allied nations had been brought back to the UK.

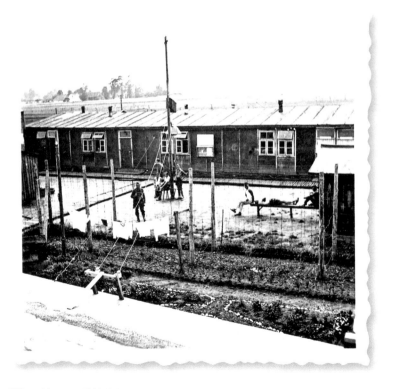

THEY WAITED FOR SIXTH ARMOURED DIVISION. *NOT FOR*
PUBLICATION
By A Military Observer *UNTIL PASSED B)*
------------------------------------- *CASUALTIES (R.O.W) WAR OFFI*

As Sixth British Armoured Division pressed on towards the
Austrian frontier in the van of 8TH· ARMY; the news filtered
through to over 100 British and Dominion Prisoners in the Camp
ARB. KDO. 11072/G.W. at GRADNITZ - EBENTAL, near KLAGENFURT.
Two days before the arrival of our men the Germans allowed the
prisoners to move about freely in the town. As our mobile
Columns entered KLAGENFURT and while the Divisional Commander
was accepting the surrender of the German Corps Commander in the
barracks, the freed Prisoners of War were thronging the streets to
greet Sixth Armoured Division.

A British Corporal took me down to the Camp. The Union
Jack was flying. The men had put it up that morning, despite
the threats of S.S. men· These S.S. were marching to Captivity
and had not yet been disarmed· They avowed their intention of
shooting down the flag. Luckily for them, discretion prevailed
and the flag was left flying.

Photographs shown here, give some idea of the conditions
under which these prisoners have lived for nearly four years·
Most of them were captured in Greece or Crete. They told me that
for the first six months they had a particularly hard time. During
that time, their weekly ration - and Red Cross Parcels had not yet
begun to come throught - consisted of the following: Bread and
Biscuits, 1 lb; Rice, 1 lb. 8 ozs., Sugar and Honey 1 1/2 Ozs.,
Salt fish, 2 oz., Tomato Purée 6 OZ: Total 2 lbs. 14 1/2 oz.
After their captured they marched for 5 days with practically no
food. Again, en Route for Austria they entrained with only a tin
of Bully and 2 Biscuits each· They were given nothing else excep
Water and Soup by The Yougoslav Red Cross at Belgrade. During
their early days in Austria, the food situation was acute.
They were given equal rations with the German soldiers and sometimes
more· Nevertheless, this was on the starvation level. Then the
Red Cross Parcels began to come through and these saved their lives·

Working on the Railway, constructing their own Air Raid
Shelter, making a Soccer Pitch, organising concerts, marching in
the village on Armistice day, burying a Comrade, these men from
all over the Empire, lived in complete harmony, with a firm
determination to show the German the kind of men the British are·
...................y day with two
They were obtained from Austrian artisans and a Crystal
set made in the Camp. These sets were concealed in ingenious places
during the numerous searches .

The camp has now been taken over by the 2nd. Battalion the
Rifle Brigade who were the first 8TH ARMY TROOPS into AUSTRIA. The
men loook extremely fit and their one thought is to get home as
soon as possible.

800 Words. A.F.P.U. and P.Ws own Photographs.

◀ An account of
the conditions
of Stalag VIII,
supported by
a collection of
photographs.
WO 361/1875

A POW
revealing the
hiding place of a
radio in a camp.
WO 361/1875

Later, after the Japanese surrender in August 1945, POWs and internees were quickly returned to their home countries, and their medical and psychological care came to be the focus of activities. Soon, attention also turned to justice for war crimes that had been committed by Axis forces on prisoners and internees.

The UK started releasing internees in late 1940 and 1941, well before the end of the war. Many Allied internees in Germany and the Far East, however, had to wait until 1945 or 1946 to return home.

Returning home was a joyful occasion for many but others struggled to adapt and reintegrate into society. The authorities did attempt to understand the psychological hardships associated with captivity and put in place schemes to help those in need.

Plans had been discussed and established years before the repatriation of POWs. Units, such as Civil Resettlement Units, were set up to help prisoners and internees on their return to the UK and to civilian life. Evacuation plans – Operation Exodus for those repatriated from Europe and the Recovery of Allied Prisoners of War and Internees (RAPWI) for the Far East – went into action immediately after peace was declared.

Repatriation

'The primary aim must be to get the released prisoners of war home as quickly as possible. The possibility of making air transport available must be ascertained. At the same time it is thought that, in the case of United Kingdom personnel, repatriation by sea has advantages over air passage. From experience of previous repatriation operations in Europe, it is evident that the effect of a long sea voyage is very beneficial. For present purposes it would have the additional advantage of convalescence en route. If air transport were employed it would certainly be necessary to stage a large proportion of the total in transit bases for recuperation before they were fit for the long voyage by air, so that even in point of time saved there is little to be gained by the use of air transport.'

➤ Plans for the repatriation of British Commonwealth prisoners of war recovered from the Far East, 1945.
WO 32/10747

COPY.
SUPREME HEADQUARTERS
ALLIED EXPEDITIONARY FORCE
Office of the Supreme Commander.

15th June 1945.

Dear Air Chief Marshal,

The record of your Command, in flying repatriates out of Germany
and from continental bases to England, is one that I wish to
commend most highly.

Your lift of some 75,000 allied repatriates during April and
May, using aircrews trained, and aircraft designed, for night
bombing, is an achievement of great magnitude, comparable to
the remarkable results of the offensive war waged by Bomber
Command.

The assistance rendered by your Command not only greatly
accelerated the return of many British repatriates to their
home, but it also relieved the over-worked transport aircrews
and aircraft.

For this great achievement in a strange role, please convey to
all your air and ground crews who took part, and particularly
to those who worked so hard at airfields at Rheims and Brussels,
my sincere compliments and thanks. It was a contribution to
human happiness of which the Air Force can remain forever proud.

Sincerely

(signed) DWIGHT D. EISENHOWER.

Air Chief Marshal Sir Arthur T.Harris, G.C.B., O.B.E., A.F.C.,
Air Officer Commanding-in-Chief,
R.A.F. Bomber Command.

◄ Draft letter
to the Air
Chief Marshal,
Sir Arthur Harris,
from Dwight
D. Eisenhower,
Supreme
Commander of
the Allied forces,
thanking Bomber
Command for
their efforts
during the
Operation Exodus
repatriation of
POWs, June 1945.
AIR 14/1432

The release of Axis POWs at the end of the Second World War was also
an enormous undertaking. Prisoners were required for labour in the UK
and stayed for years after the war. Others remained in captivity, either
because they were tried for war crimes, or because they undertook a
period of re-education and de-Nazification before their release.

'Priority is being given to anti-nazis and, conversely, those holding nazi views are excluded from the Scheme. A systematic check will be kept on the latter class and all who are found to have genuinely changed their views will become eligible for repatriation.'

46B

Details of Scheme for the Repatriation of German
Prisoners of War from the United Kingdom.

The Scheme started to operate at the end of September.

The overall rate for the present is 15,000 a month.

The Scheme, in general, is designed to send Prisoners home according to the length of time spent in captivity. There are, however, a number of factors which determine priorities and the composition of monthly quotas. These are:-

(a) Political

Priority is being given to anti-nazis and, conversely those holding nazi views are excluded from the Scheme. A systematic check will be kept on the latter class and all who are found to have genuinely changed their views will become eligible for repatriation.

(b) Economic

To meet Germany's need for certain categories of workers a quota of such men will be included when required.

(c) Compassionate Cases

A limited number will be given early repatriation for family or other compassionate reasons. These will be nominated by the authorities in Germany (Scheme has been worked out for the British Zone, other zones have been invited to participate. We are aiming at a monthly allotment of 500)

(d) Allied Zones

Intention is to give equal priority to all zones. Allied authorities have been asked to accept; replies are awaited.

(e) Compulsory Deferment

Prisoners, qualified politically for repatriation, will only be compulsorily deferred for two reasons:-

(i) It will not be possible to repatriate, in strict accordance with length of captivity, certain Prisoners such as Doctors, Dentists, Pastors, Priests and medical orderlies required for the welfare of Prisoners in the United Kingdom.

(ii) Men who habitually misconduct themselves will not be sent home on equality with their well conducted comrades. Men so relegated will be informed and be given an opportunity of regaining their place in the repatriation roster by improvement in their behaviour.

(f)

> 'Details of Scheme for the Repatriation of German Prisoners of War from the United Kingdom', 1946. FO 945/449

III Return and Rehabilitation of British Captives

Plans had been put in place for the rehabilitation and reintegration of POWs returning to the UK from Europe and the Far East. Former prisoners were advised on things like diet – so important when so many had such limited access to food when in captivity – while their families were provided with advice on how to approach the subject of their imprisonment and its potential psychological effects. Former captives were medically examined upon their return to the UK, given a period of leave and, once their military service was deemed to be completed, given guidance on their return to civilian life.

◄ Front page of the 'Settling Down in Civvy Street' booklet issued to repatriated POWs, which provided tips for their reintegration into society, 1945. WO 32/10757

➤ 'Hints on Diet During Recuperative Leave for Liberated Prisoners of War', May 1945. WO 32/10757

/126A

HINTS ON DIET DURING RECUPERATIVE LEAVE
FOR LIBERATED PRISONERS OF WAR

As a result of the privations you have endured as a prisoner of war, you have probably lost weight, and it is natural to think that the more food you eat the sooner will you recover your lost weight and strength. But you must remember that your physique as well as your weight may be temporarily below par, and this includes your digestive system. Just as you need rest at first and your muscles require gradual retraining, so your digestive system requires rest at first and then retraining in the handling of the sort of foods you normally like to eat.

To get your digestive system back to normal as quickly as possible, a few simple rules that you should follow, especially if you are having trouble with your digestion, are given in the dietetic instructions below. You should show these notes and the following instructions to anyone who is giving you your meals, so that they can understand why you have to be careful about eating for a time, and what they should give you to eat.

(1) **Don't overload your stomach.** Avoid heavy meals, and instead, eat small amounts frequently. Try eating three light meals a day, with three snacks of the biscuits and milk variety —two between meals and one last thing at night.

(2) **Remember that your digestion is weak, and at first give your stomach foods easy to handle.**

Eat : Foods such as milk and milk puddings, eggs, cereals, toast or bread, biscuits, preserves, cake, and fish and tender meat if you can eat these without discomfort.

Avoid at first : Fatty or fried foods, bulky vegetables, raw salads or fruit, highly seasoned dishes, twice-cooked meats, pickles and spices, rich, heavy puddings and pastries, strong tea and coffee.

Beer and other alcoholic drinks are hard on a weak stomach, and you should take these very sparingly, if at all, for the first few days at least.

Telephone Nos.
REGENT 6050.
WHITEHALL 6789.

BOX No. 500,
PARLIAMENT STREET B.O.,
LONDON, S.W.1.

SF.91/5/3/A.D.D.4.

21st September 1944.

Dear Allchin,

We spoke yesterday as to the repatriation of British subjects freed from internment in France. You agreed that you would furnish us with nominal rolls and also that questionnaires completed by the Consul General would be furnished in respect of each individual which would also be passed to us. You also agreed that you would arrange that 48 hours notice should be given of the departure of any individual which would enable you to inform us which of the individuals whose questionnaires were in our possession, we might expect.

You also said that you would arrange with the Consul General that not more that 20 individuals would be sent over each day.

I take it that these arrangements will apply to all British subjects including those from the Dominions. Some Canadians have arrived and amongst them individuals whom the enemy has permitted to remain at liberty.

The arrangements which were in force through you with the Repatriation Office at Lisbon were extremely helpful and yielded concrete results, it is hoped therefore that the arrangements outlined above which are very much the same can be put into force. The essence, of course, is that we should get the Consul General's report on the individual before arrival and that we should know whom to expect. The system of endorsement of passports by the Consul General, with the appropriate secret signal, will of course apply, as this will be helpful in cases where no prior advice has been received.

Yours sincerely,

C.H. Burne, Lt. Col.
for Colonel J.H. Adam.

P.S. I have asked Miss Syfret for the questionnaire forms

◀ Repatriation of internees from France, ensuring safe travel and reunion with those they were separated from in the UK, 21 September 1944.
FO 369/2960

The Foreign Office was responsible for repatriating UK civilian internees from camps in what had been German-occupied territory. Most were released and repatriated from the summer of 1944 until the end of the war, though many who had previously settled in Europe chose to remain there now it had been liberated.

IV Disbanding MI9

By early 1944, IS9 had formed a new section known as WEA (Western European Area). James Langley, a former MI6 agent whose task at the beginning of the war was to liaise with the newly formed MI9, was put in charge of processing the release of POWs. The plan known as En-Dor was

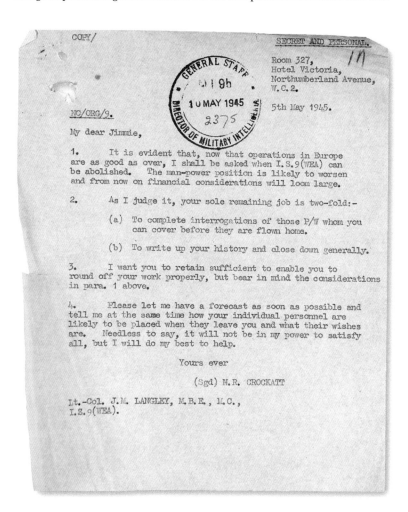

COPY/

SECRET AND PERSONAL.

Room 327,
Hotel Victoria,
Northumberland Avenue,
W.C.2.

NC/ORG/9.

10 MAY 1945

5th May 1945.

My dear Jimmie,

1. It is evident that, now that operations in Europe are as good as over, I shall be asked when I.S.9(WEA) can be abolished. The man-power position is likely to worsen and from now on financial considerations will loom large.

2. As I judge it, your sole remaining job is two-fold:-

 (a) To complete interrogations of those P/W whom you can cover before they are flown home.

 (b) To write up your history and close down generally.

3. I want you to retain sufficient to enable you to round off your work properly, but bear in mind the considerations in para. 1 above.

4. Please let me have a forecast as soon as possible and tell me at the same time how your individual personnel are likely to be placed when they leave you and what their wishes are. Needless to say, it will not be in my power to satisfy all, but I will do my best to help.

Yours ever

(Sgd) N.R. CROCKATT

Lt.-Col. J.M. LANGLEY, M.B.E., M.C.,
I.S.9(WEA).

> Crockatt's
letter ordering
the disbanding
of the IS9 (WEA)
section of MI9.
WO 208/3255

to be exercised as quickly as possible, which meant that interrogations of POWs needed to be swift and efficient.

In early May 1945, Brigadier Norman Crockatt wrote to Langley telling him of the impending 'abolition' of IS9 (WEA). Langley replied with 'Plan Kleenup', along with his letter of response, which was coolly received. He wanted his personnel to transfer to other areas of MI9 prior to demobbing, singling out Airey Neave and a handful of other agents with specific skills that would be useful for future intelligence work.

Many of Langley's personnel, mostly airmen who had been trained and recruited to work for IS9 in interrogation methods, found themselves tasked with interrogating POWs and filling out liberation questionnaires. Some responses were defiant and others so compliant that the testimonies took a long time to complete. Already understaffed,

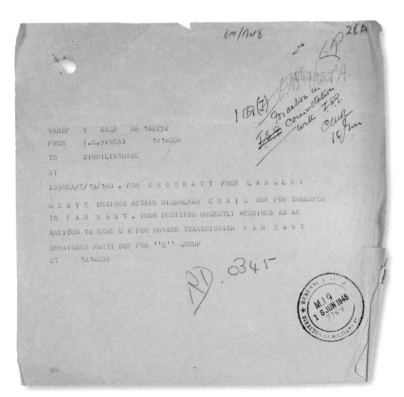

◄ Telegram from Langley to Crockatt regarding Airey Neave's wish to continue his work in Europe. WO 208/3255

Langley was put under pressure by Crockatt and ordered to 'write up your history and close down generally' by the end of June 1945.

MI9's work continued until the end of the war. Much of its history is well known, thanks to the release of many official records at The National Archives. The vast number of interrogation reports held here can often feel overwhelming, but every report has a unique story to tell.

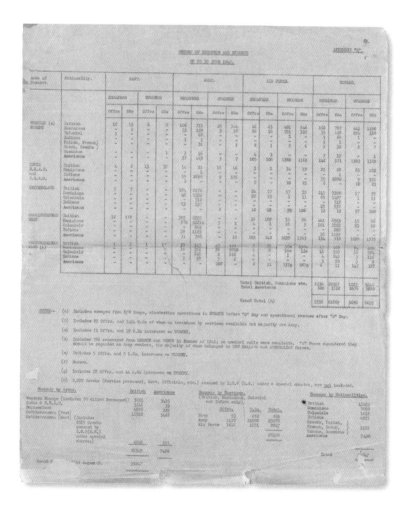

➤ Record of Escape and Evasion from MI9's official history. WO 208/3242

V Civilian Internees Captive in Britain

The torpedoing and sinking of SS *Arandora Star* en route to Canada in July 1940 was a significant point in the policy of internment in the UK. On board were 734 Italians, 438 Germans (including both Nazi sympathisers and Jewish refugees) and 374 British seamen and soldiers. Over half lost their lives, including 470 Italians.

It was this event that swayed public sympathy towards the enemy aliens. The release of 1,687 enemy aliens was authorised in August 1940 and by October about 5,000 Germans, Austrians and Italians had been released following the publication of the Under Secretary of the Home Office, Osbert Peake's white paper 'Civilian Internees of Enemy Nationality'. The paper identified categories of persons who could be eligible for release. By December, 8,000 internees had been released and, of these, over 1,300 men had joined the Auxiliary Military Pioneer Corps. They would be joined by internees in Canada and Australia, but here the process of release would take longer. By 1942, fewer than 5,000 remained interned, mainly on the Isle of Man, most of whom were Nazi or Italian Fascist sympathisers.

Even before the war ended, many thousands of internees, especially in the UK, had been permitted release, largely because any potential threat had reduced as the war progressed. So, what happened after the internees were released? Most would stay in Britain until the end of the war in 1945 and then many successfully applied for British nationality; women who married British subjects would become British upon marriage.

However, not all of the Jewish refugees decided to stay in Britain. Some did return to Europe, but it was a very different place, with the Iron Curtain dividing it into two separate areas from the end of the Second World War until the end of the Cold War in 1991. Many went overseas to America, Canada and South Africa, and significant numbers went to Palestine and Israel, newly created in 1948.

20. Persons of eminent distinction who have made outstanding contributions to Art, Science, Learning or Letters.

(At the ~~suggestion~~ request of the Home ~~Office~~ Secretary special committees to consider the cases of artists, architects and men of Letters and submit recommendations to him have been set up ~~by~~ the Royal Academy, the Royal Institute of British Architects and the P.E.N. Club. Committees to consider and submit recommendations relating to the cases of Musicians and Lawyers have been appointed under the chairmanship of Dr. ~~~~Williams, O.M. and the Right Honourable Justice Scott, ~~~~ respectively. Applications for ~~committees~~ release under this category ~~should be~~ ~~submitted through these~~ ~~appropriate Committees~~ will be referred by the Home Office to the

21. Students who, at the time of their internment, were pursuing a course of study at a university or a technical college, provided that the vice-chancellor of the university or the head of the college certifies that it is desirable that the student should continue his studies at the university or college and that the circumstances are such that ~~the~~ a British student would, in similar circumstances, be allowed to continue his studies.

(Applications for release should be accompanied by the required certificate).

22. Any person as to whom ~~the~~ a Tribunal, appointed by the Secretary of State for the purpose, reports that he has, since his early childhood, or for at least 20 years, lived continuously, or almost continuously in the United Kingdom; that he has long severed connection with his country of nationality; that his interests and associations are British and that he is friendly towards this country.

(An application for release should give sufficient particulars ~~of~~ of the alien's history to indicate that he is a person who comes within this category. The application will be referred by the Home Office to the Tribunal who, after considering all the information available, will advise the Secretary of State whether the applicant is eligible for release.)

HOME OFFICE

GERMAN AND AUSTRIAN
CIVILIAN INTERNEES

Categories of Persons Eligible for Release
from Internment
and
Procedure to be Followed in Applying for Release

Presented by the Secretary of State for the Home Department
in Parliament by Command of His Majesty
July, 1940

LONDON
PRINTED AND PUBLISHED BY HIS MAJESTY'S STATIONERY OFFICE
To be purchased directly from H.M. STATIONERY OFFICE at the following addresses:
York House, Kingsway, London, W.C.2; 120 George Street, Edinburgh 2;
26 York Street, Manchester 1; 1 St. Andrew's Crescent, Cardiff;
80 Chichester Street, Belfast;
or through any bookseller
1940
Price 1d. net

Cmd. 6217

▲ Command paper 6217 identifying categories of persons eligible for release from internment and the procedure to be followed in applying for release, July 1940. HO 213/1717

◀ One category of release related to 'Persons of eminent distinction who have made outstanding contributions to Art, Science, Learning or Letters'. HO 213/1717

VI Empty Spaces

After the war, many of the camps that were requisitioned by governments went back to their former use. The racecourses at Kempton Park and Lingfield, which had been used to intern civilians and as POW holding camps, were restored, and the camps at Paignton and Seaton returned to being a zoo and holiday camp, respectively.

A lot of the POW camps were simply dismantled, as they had been temporarily built for the duration of war; however, a few found new uses, such as Eden Camp in North Yorkshire, which became a modern history centre and museum. On the Isle of Man, hotels requisitioned for the confinement of internees became hotels again, although much has been preserved by the Manx Government to tell the story of internment to future generations. In Southeast Asia, the situation was similar in that many POW and internment camps either went back to their previous uses – as barracks or prisons – or were dismantled.

The picture was more complicated on mainland Europe. Many of the camps were located behind the Iron Curtain, where access was not easy for POWs or their descendants who wanted to visit the sites. Twenty-five miles south-east of Leipzig, Colditz Castle became part of the newly created East Germany. In 1949 the government turned it into a prison for local criminals. Later, the castle became a nursing home and a hospital and psychiatric clinic. After the fall of the Berlin Wall in 1989, the site underwent further transition. During 2006 and 2007, the castle was significantly refurbished and now includes a museum that offers guided tours showing some of the escape tunnels.

In the Far East, the Hong Kong Correctional Services Museum now occupies the site of the Stanley Internment Camp and part of the museum is dedicated to the camp and those who were interned there.

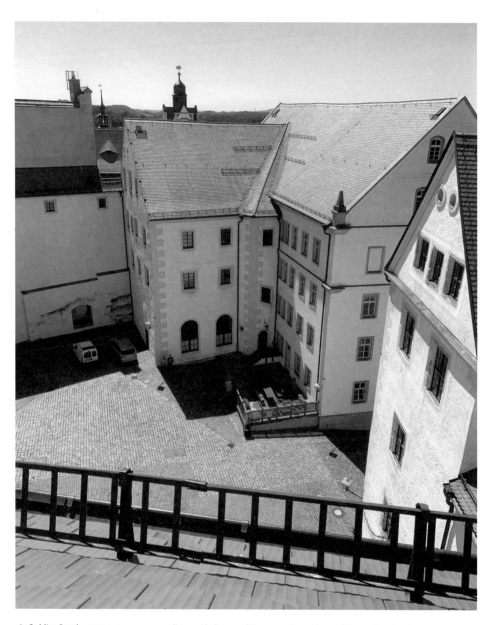

∧ Colditz Castle, now a museum providing guided tours. (Photograph courtesy of Roger Kershaw)

VII War Crimes Trials and the Third Geneva Convention

Many of those involved in the abuse of POWs, both in Europe and the Pacific, were prosecuted as part of the wider war crimes trials of Axis personnel at Nuremberg and Tokyo. In Europe, those responsible for the treatment of POWs during the 'Long March' were especially targeted, as were those accountable for the murders of POWs throughout the war. In the Pacific, crimes related to the treatment of POWs became the focal point, largely because their mistreatment was so severe.

◄ Front cover of the record relating to the investigation into the ill-treatment and murder of Allied POWs during the 'Long March', 1946. WO 309/47

'In March or April 1943 I was in Lintang Camp when a working party were being dismissed. A man was being carried off on a stretcher. On inquiry of some onlookers what was happening, they told me that the man was Gunner PRIKE. He had been found, when searched, with some coffee in his water bottle and a Japanese two-star soldier GUNZO had hit him over the temple with the bottle. I saw a pool of blood on the ground about one and a half square feet in extent. Gunner PRIKE died two weeks later. Sapper NORTH of The Bungalow, Cumberworth, Near Alford, Lincoln witnessed the incident. GUNZO was about five foot six inches in height, medium in build, but I cannot remember anymore about him.'

MD/JAG/FS/JC/115(1C).

IN THE MATTER OF THE ILL-TREATMENT OF
PRISONERS OF WAR AT KUCHING, BORNEO.

British National Office Charge No:-

United Nations War Crimes Commission Reference:-

A F F I D A V I T.

I, ERNEST LIONEL MORRIS make oath and say as follows:-

1. My Number is 1671488 and I am a Sapper in the Royal Engineers at present attached to Number 2 Civil Resettlement Unit at Peover Hall, Knutsford, Cheshire with home address at "Alan Mount", Ash Lane, Hale, Cheshire.

2. I was captured on 15 February 1942 at Singapore.

3. On 19 February 1942 I sailed in a twelve foot pram dinghy from Singapore to The Sunda Straits with Major CAMPBELL and Lieutenant MARTIN, Royal Artillery. We were caught by a Japanese Cruiser on 5 March 1942.

4. After being in about half a dozen camps I arrived on the 14th October 1942 at LINTANG Camp, Kuching. I stayed here until 4 June 1943. After this I was at Kuching Aerodrome until 29 March 1945 with a break in a KEMPI TAI (Gestapo) Cell from 4 June 1944 to 3 August 1944. On 29 March 1945 I returned to Lintang Camp until 13 September 1945.

5. Gunner PRIKE, Royal Artillery.

In March or April 1943 I was in Lintang Camp when a working party were being dismissed. A man was being carried off on a stretcher. On inquiry of some onlookers what was happening, they told me that the man was Gunner PRIKE. He had been found, when searched, with some coffee in his water bottle and a Japanese two-star soldier GUNZO had hit him over the temple with the bottle. I saw a pool of blood on the ground about one and a half square feet in extent. Gunner PRIKE died two weeks later. Sapper NORTH of The Bungalow, Cumberworth, Near Alford, Lincoln witnessed the incident. GUNZO was about five foot six inches in height, medium in build, but I cannot remember anymore about him.

6. KEMPI TAI.

Between 4 June 1944 and 3 August 1944 I was in the cells of the Kempi Tai in Kuching City as a result of the finding, during a search, of a diary which I had made. It was ten months after this finding that I was summoned by the Japanese and at my interrogation prior to going to the cells I was kicked about and threatened with death. I could identify my interrogators if I saw them but any description I could give would fit almost any Oriental. As far as I know, the Japanese thought that the P.O.W. and internees in Lintang Camp and on Kuching Aerodrome were intending to co-operate with local Chinese in a mass rising. There had been a mass rising of Chinese at JESSELTON (API API) in about March 1944. As a result of this fear the Kempi Tai had pulled in to the cells in Kuching Serjeant BERT, Gordon Highlanders (who had been caught in possession of local Chinese and Malay newspapers), Gunner GOLDSBROROUGH, Royal Artillery, (Assistant to BERT), Doctor STOOKS, M.C., (formerly Royal Flying Corps and an internee), KIRNIBER (a Dutch internee), and WEBBER (an American internee), all from Lintang. From the Kuching Aerodrome I (probably owing to my diary), Dutch Warrant Officer HUSING (from PONTIANAC, who had contacted Chinese civilians), HART SINGH, SCHMIDT (both Dutch Army), and a Dutch Interpreter whose name I have forgotten, were also pulled in. In addition there was present Mr. CHAO (the Chinese Consul in Sarawak).

/In the cells

➤ Testimony about the ill-treatment of POWs at Kuching Camp in Borneo, 1946. WO 325/39

In the cells we were roused at daybreak and made to sit all day, except for brief exercise and meals, on board with our legs crossed. Talking was forbidden and, if caught talking, we had to stand on our hands until falling when we were beaten with sticks. We had two meals per day of rice porridge. On one occasion I was pinned to a table and filled with water (6-7 pints). A plank was laid across my stomach and a Japanese Military Policeman sat on each end until I vomited the water out. Twice I was made to kneel blind fold as if for execution. I was kept kneeling thus and then the Japanese placed jokingly the flat of a sword on the back of my neck. I cannot describe the two Japanese primarily responsible, save to say that one looked European and the other had a bald head. On 3 August 1944 I, SCHMIDT, and the Dutch Interpreter were sent back to Kuching Aerodrome. The remainder of the party were sent, I am pretty sure, to the Kempi Tai Headquarters at Jesselton.

7. The Jesselton Murders.

I believe that the following were killed:- WEBBER, Dr. STOOKS, KINNIBER, HUEING, Serjeant BENT, and Gunner GOLDSBOROUGH.
In about October 1944 the Japanese reported that HART SINGH had died of a stomach complaint.
When I was at LABAUN in early October 1945 I met Bishop HOLLIS of LABAUN and Mr. TUXFORD, an internee, and from them it was that I came to think that the six men above were dead. Mr Tuxford's son who had been in Jesselton and not interned gave information that BENT, GOLDSBOROUGH and STOOKS were alive in early July 1945. The Bishop told me that the nineth Australian Division had located graves at Jesselton believed to be those of the six men.

8. Kuching Aerodrome Camp.

The conditions at this camp were similar in their unpleasant-ness to those of any other camp. There was a Japanese Corporal HIAYAMA, known to us as "Rastas". He was very tall and walked with a stiff leg and a slight stoop. He was European in appearance with a comparitively sharp nose. Diabolical, he was responsible for numerous acts of sadism, particularly after the first air-raid on Kuching Aerodrome. On this occasion he went out of his way to knock out with a stick Serjeant BAKER of the Indian Army Ordnance Corps. Very often with this stick he hit people about the head and another favourite pastime of his was to throw flints at them.

9. Lintang Camp.

The Australian 9th Division seized in September 1945 a number of documents which laid down the policy to be adopted by the Japanese against P.O.W. and internees in the event of Allied invasion of Sarawak. No doubt the intelligence section of this Division know of the premeditated horrors. Up to the end of 1944 the deaths at Lintang numbered in toto 89. From January 1945 to the end of the war the monthly death rate was approximately as follows:- January, 38; February, 47; March, 52; April, 68; May, 89; June, 114; July, 137; the total strength of the camp was 1300.

10. The foregoing facts are to my own knowledge true except where the contrary appears and in such case the facts are true to the best of my information and belief and my means of knowledge is recorded in this my affidavit.

SWORN at Chester in the County of Chester this twentieth day of March 1946.) Ernest Lionel Morris.

Before me,
A.S. Roberts
Captain Legal Staff.
Military Department.
Office of the Judge Advocate General.

> Front cover of the diary kept by Major Nashiro, staff officer in Malaya, used as part of evidence during the war crimes trials on the treatment of Allied POWs, 1941–45.
WO 325/169

The Third Geneva Convention, 1949

The events of the Second World War highlighted the consequences of there being no provision in international law for the protection of civilians; the Third Geneva Convention, adopted in 1949, sought to correct this. When adopted by signatory nations, alongside the inclusion of specific articles relating to the protection of civilians in occupied territories, principally the provision for humanitarian relief, it also included specific obligations relating to civilian internees and their treatment.

Geneva Conventions of 12 August 1949 for the protection of war victims

'Persons taking no active part in the hostilities, including members of the armed forces who have laid down their arms and those placed *hors de combat* by sickness, wounds, detention, or any other cause, shall in all circumstances be treated humanely, without any adverse distinction founded on race, colour, religion or faith, sex, birth or wealth, or any other similar criteria.'

CONVENTIONS
DE GENÈVE

DU 12 AOUT 1949
POUR LA PROTECTION DES VICTIMES
DE LA GUERRE

GENEVA
CONVENTIONS

OF AUGUST 12, 1949
FOR THE PROTECTION OF WAR VICTIMS

◄ The international convention signed in Geneva on 12 August 1929. FO 93/1/401

Conclusion

Never before had so many people across the globe been taken into captivity. Millions of service personnel became prisoners of war while hundreds of thousands of civilians became internees stripped of their liberty for no reason other than that their nationality was deemed to be the enemy and therefore hostile. Selection did not discriminate. Anyone – the young, the old, male and female of all occupations – would be placed into camps because they were in the wrong place at the wrong time.

Wherever they were captured, what unites prisoners of war and civilian internees is their amazing stories of resilience, strength, friendship, hope and survival. While some were only held captive for weeks, others would be deprived of their liberty for the entire period of war, testing their human spirit.

The stories and documents featured in this book only give a small insight; but, increasingly, historical documents across the globe are being declassified, opened, catalogued and digitised to understand more about life in captivity during the Second World War.

Appendix

Help With Your Own Research

The records presented in this book are a small selection of the material available at The National Archives that relate to POWs and internees during the Second World War. They include records of high-level decision-making; reports produced by the Red Cross when inspecting POW and internment camps; reports on escapes; investigations into war crimes; and an array of personnel records, principally for individuals from the Allied nations involved in the conflict.

Some of this material was produced by the British Government or its representatives, while other material was assembled by other nations, especially Germany and Japan, in its administration of the captives under its control. The latter was either sent back to Britain after the war, as set out in the Geneva Convention, or was recovered in the post-war period. Likewise, Britain and its Allies sent personnel records relating to Axis POWs back to their countries of origin, while additional material produced by the Red Cross as part of its role aiding the protective powers, principally Switzerland, was also retained centrally. As such, other records may also be found in archives and museums internationally.

Here we have provided research guidance for records held at The National Archives on this subject and the different records series in

which they may be found, as well as where other relevant records may be located. More details about records held at The National Archives can also be found in the relevant research guides on their website.

British and Commonwealth Prisoners of War

ADM 358: enquiries into missing naval personnel in both Europe and Southeast Asia

AIR 40: reports and information about Royal Air Force POWs who escaped or evaded capture

AIR 81: enquiries into missing air force personnel in both Europe and Southeast Asia

BT 373: Registry of shipping and seaman; POW records of Allied merchant seamen

FO 950: Compensation claims files for those British nationals who suffered Nazi persecution. This series includes claims from POWs and civilian internees

WO 208: escape and evasion reports, which give individual accounts of escape attempts or capture or awards for those who assisted escape attempts; special questionnaires made by individuals about the work of escape committees, escape aids, German censorship and a collection of geographical information that assisted future escape attempts

WO 222: medical historian's papers from the Second World War, including details of medical care for POWs in Southeast Asia

WO 224: POW camp reports compiled by the Red Cross and sent to British authorities, providing details about camp conditions

WO 309: war crimes investigations into the mistreatment of POWs in north-west Europe

WO 311: Judge Advocate General's office records on war crimes investigations into the mistreatment of POWs in Europe and Southeast Asia

WO 325: war crimes investigation files for POWs and internees held in Southeast Asia

WO 344: approximately 140,000 liberation questionnaires completed by British and Commonwealth POWs of all ranks and services held in Europe and Southeast Asia

WO 345: approximately 50,000 Japanese index cards for British and Commonwealth POWs

WO 347: selected hospital registers listing details of patients in POW and internment camp hospitals in Southeast Asia

WO 361: enquiries into missing army personnel in both Europe and Southeast Asia

WO 367: lists of approximately 13,500 Allied POWs and civilian internees held in camps in Singapore

WO 416: approximately 200,000 German record cards of British and Commonwealth POWs and some civilian internees

WO 418: escape and evasion maps produced by MI9 between 1940 and 1945

Prisoners of War in British Hands

ADM 186: interrogation reports for captured enemy naval personnel

AIR 40: intelligence reports and papers; interrogation reports for captured enemy airmen

CAB 122: correspondence with United States authorities on general POW policy

CO 968: lists of enemy POWs held in territories of the British Empire

FO 916: inspection reports on POW and internment camps in the United Kingdom

FO 939: files on individual POWs camps in the United Kingdom

FO 1050: Control Commission for Germany (British element) interrogation reports

FO 1120: student record cards of prisoners of war who attended the Wilton Park centre prior to repatriation to Germany (and occasionally Austria); German camp visit reports; and location list of POW camps in the United Kingdom

WO 177: war diaries of some POW camps, hospitals and depots, written from the purpose of camp administration

WO 199: lists of POW camps and documentation on the employment of mainly Italian prisoners

WO 208: incomplete sets of interrogation reports for enemy prisoners, mainly German held by the British authorities

Internees in Britain and Europe

FO 916: inspection reports on POW and internment camps in the United Kingdom and Europe

HO 45: registered papers including correspondence about the occupation of the Channel Islands and deportation of hundreds of civilians to camps in Germany

HO 144: registered papers including correspondence about the occupation of the Channel Islands and deportation of hundreds of civilians to camps in Germany

HO 213: policy files relating to internees and POWs

HO 214: small selection of case files for internees held in the United Kingdom

HO 215: welfare of internees and the papers relate to the treatment of internees, the health and educational facilities and their movement within the United Kingdom and abroad. The series also includes nominal rolls for various internment camps on the Isle of Man

HO 382: British Aliens Department personal files; some may include internment papers of foreign citizens interned in the United Kingdom

HO 396: British Aliens Department; German, Austrian and Italian internee index cards

HO 405: British Aliens Department applications for naturalisation; some may include internment papers of foreign citizens interned in the United Kingdom

KV 2: British Security Service personal files, including the records of some internees

PCOM 9: lists of internees held in the United Kingdom

WO 416: approximately 200,000 German record cards of British and Commonwealth POWs and some civilian internees

Internees in Southeast Asia

CO 980: correspondence and reports on conditions in internment camps under Japanese authority

CO 1070: Prisoners of War and Civilian Internees Department; nominal index of Allied internees held in Hong Kong and Malaya

FO 916: reports compiled from various sources on internment camps

WO 347: selected hospital registers listing details of patients in POW and internment camp hospitals in Southeast Asia

WO 367: lists of approximately 13,500 Allied POWs and civilian internees held in camps in Singapore

Records Held in Other Archives

Information about POW and internment camps may be held in local archives around the United Kingdom and these archives can be searched on Discovery, The National Archives catalogue. Details regarding records collections available from other museums and archives are provided below.

Bundesarchiv, Germany: records of German POWs held by the Allied nations

Eden Camp Modern History Museum: former POW camp; holds records of Allied and Axis POWs

Imperial War Museum: holds a large collection of personal records and oral history testimonies of Allied POWs and internees, as well as collections of photographs

The International Committee of the Red Cross: holds information on all known prisoners of war and internees of all nationalities affected by conflicts during the twentieth century

Library and Archives Canada: records relating to civilian internees deported to Canada

Manx National Heritage: records relating to civilian internment on the Isle of Man

Ministero della Difesa, Italy: records of Italian POWs held by the Allied nations

National Archives of Australia: records relating to civilian internees deported to Australia

Powerhouse Museum, New South Wales, Australia: records relating to civilian internees deported to Hay and Orange camps, New South Wales

Schloss Colditz: former POW camp, now a museum

Stalag Luft III Museum: former POW camp, famous for the Great Escape, now a museum

Further Reading

Internment

Cesarani, David, and Kushner, Tony, *The Internment of Aliens in Twentieth-Century Britain* (Routledge, 1993)

Chappell, Connery, *Island of Barbed Wire* (RBJT6, 2005)

Gillman, Levi, *Collar the Lot! How Britain Interned and Expelled its Wartime Refugees* (Quartet Books, 1980)

Kochan, Miriam, *Britain's Internees in the Second World War* (Palgrave Macmillan, 1983)

Parkin, Simon, *The Island of Extraordinary Captives* (Sceptre, 2022)

Tyrer, Nicola, *Stolen Childhoods: The Untold Story of the Children Interned by the Japanese in WWII* (Weidenfeld & Nicolson, 2011)

POWs

Custance Green, Hilary, *Surviving the Death Railway: A POW's Memoir and Letters from Home* (Pen and Sword, 2016)

Gilbert, Adrian, *POW: Allied Prisoners in Europe 1939–1945* (John Murray, 2006)

Macintyre, Ben, *Colditz: Prisoners of the Castle* (Penguin, 2022)

MacKenzie, S.P., *The Colditz Myth: British and Commonwealth Prisoners of War in Nazi Germany* (Oxford University Press, 2004)

Makepeace, Clare, *Captives of War: British Prisoners of War in Europe in the Second World War* (Cambridge University Press, 2017)

Parks, Meg, *Captive Memories: Far East POWs & Liverpool School of Tropical Medicine* (Palatine, 2015)

MI9

Bond, Barbara, *The Times Great Escapes* (Times Books, 2015)

Foot, M.R.D., and Langley, J.M., *MI9 Escape and Evasion* (Biteback Publishing, 2020)

Fry, Helen, *MI9* (Yale University Press, 2021)

Imperial War Museum, *Most Secret: M.I.9 Escape and Evasion Devices* (IWM, 2023)

Neave, Airey, *Saturday at MI9* (Pen and Sword, 2010)

Acknowledgements

The idea for this book was conceived from our recently catalogued collections that inspired the exhibition *Great Escapes: Remarkable Second World War Captives*. It would not have been possible without the work of our volunteers and staff, who have tirelessly catalogued The National Archives' collections in the CO 1070, WO 208 and WO 416 series. Their work has enabled us to research in depth some of the personal stories of POWs and internees. Our thanks especially to Pad Kumlertsakul, Keith Mitchell, Katrina Lidbetter and Pete Helmore, who put so much of their own time into researching these histories. Our thanks also to Sarah Patterson and Steven Walton from the Imperial War Museum for their support and advice.

Thanks also to staff at The National Archives, who supported us in this project: in particular to the Exhibitions and Digitisation teams, and to Kirsty Schaper in Licensing and Publishing for her encouragement and support.

We have had wonderful support from experts and the relatives of captives mentioned in this book, and so our heartfelt thanks go especially to David Bellis, Ghee Bowman, Tyler Butterworth, Brett Exton, Mark Hickman, Patrick Neave, Colin Tosh and Douglas Ward.